The UFO Show

artists:

George Blaha, John Brill, An[n]
Detskas, Sharon Engelstein, Joy Garnett, Keith
Haring, Lance Horenbein, Claire Jervert, Christopher
Johnson, Jeremy Kidd, Paul Laffoley, Mariko Mori,
Panamarenko, Cynthia Roberts, Kenny Scharf, Ionel
Talpazan, Oliver Wasow, Kenneth Weaver,
and Amy Wilson

Exhibition curated by Barry Blinderman and Bill Conger

Writings by Barry Blinderman, Paul Laffoley, Bill McBride,
Carlo McCormick, Rudy Rucker, and Amy Wilson

university galleries

The **UFO** Show was curated by Barry Blinderman and Bill Conger.

Design: Bill Conger and Barry Blinderman
Editor: Barry Blinderman
Production assistance: Angela Barker, Dave Kuntz, Bill McBride, Matt Pulford,
 Karl Rademacher, Amy Wilson and Eric Yeager
Publisher: University Galleries of Illinois State University
Distributor: Distributed Art Publishers, New York tel 800.338.2665
Printing: Permanent Typesetting and Printing Co., Ltd. Hong Kong

Cover: **Claire Jervert, 10/1998oz-1. Cibachrome print on honeycomb aluminum panel, 1998. Courtesy Steffany Martz Gallery.**
Frontispiece: **Sharon Engelstein, Flying Saucer (detail). Sequins, foam, and plexiglass, 1998. Collection The International UFO
 Museum and Research Center, Roswell, NM.**

exhibition itinerary:

February 29 through April 2, 2000
University Galleries, Illinois State University; Normal, Illinois

September 29, 2000 through November 27, 2000
The Arts and Science Center for Southeast Arkansas;
 Pine Bluff, Arkansas

December 15, 2000 through February 2, 2001
Gallery of Contemporary Art, University of Colorado;
 Colorado Springs, Colorado

This publication has been supported in part by a grant from the
Illinois Arts Council, a state agency.

Illinois
ARTS
Council
AN AGENCY OF
THE STATE OF ILLINOIS

**university
galleries**

illinois state university
campus box 5620
normal, il 61790-5620

gallery@oratmail.cfa.ilstu.edu
tel 309.438.5487
fax 309.438.5161
www.orat.ilstu.edu/cfa/galleries

ISBN 0-945558-30-9

The UFO Show

Foreword
Barry Blinderman

In the summer of 1998, within the span of days, I saw a voluptuous sequined UFO sculpture by Sharon Englestein in Houston, received a reproduction of one of Claire Jervert's video-derived sci-fi saucer photographs, and was sent slides of pancake-shaped sculptures with glass bubble protrusions by Jeremy Kidd, a Brit living in Los Angeles. When such "meaningful" coincidences occur, I'm curious to investigate why certain themes appear in clusters in different artists' work. I began to wonder why the image of the flying saucer, whether rendered by a five-year-old child, non-artist, or artist, always seemed to have the same ovoid shape. Was it because we all have seen the same 50s sci-fi movies or their spinoffs—whether in

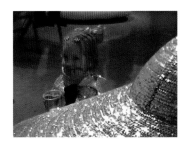

Opening reception for The UFO Show, with detail of Sharon Englestein's Flying Saucer.

toys or on TV—or did it have to do with some primal image that predates film, or for that matter was hardwired to our psyches before the dawn of the earliest civilization? Appearances of blinking ellipsoids, whirling orbs, and hovering illuminations have been reported and recorded since biblical times, and especially following the onset of atomic warfare and subsequent testing. Whether based in empirical reality, paranoiac projection, false memories, or an innate desire to realize an archetype of wholeness, UFOs have captivated the popular and artistic imagination. I am told—but have not verified the statistics—that UFO sites get the third most frequent hits on the Internet, eclipsed only by shopping and sex sites.

The term UFO was first used by the military to define any unidentified object in the sky, but it has been widely adopted by post 1950s society as a synonym for the image of the flying saucer popularized by

Keith Haring, Untitled (Fertility Suite). Silkscreen on paper, 1983. Courtesy Shafrazi Gallery.

science-fiction books and movies. Paradoxically, the mystery of the "unidentified" in the term is automatically equated with the identification of an extraterrestrial Other, while the "flying object" is as swiftly likened to the very terrestrial image of any saucer-shaped thing. (Just place two tea saucers face to face and you'll see immediately what I'm talking about.) The contradiction between the "unidentified" and the identified Other it represents—whether real or imagined—has provided fertile territory for artists fascinated by a sublime form shuttling between the atavistic and media-generated chambers of the collective unconscious.

While I'm busy throwing around Jungian terms like "collective unconscious" and "archetype"—words that might have labelled me as very

**Drawing by Gabriel Nordholm Blinderman,
ca. 1995.**

unhip during the French theory-bound 80s—I should mention that I came across a catchy reprint of Carl Jung's *Flying Saucers* (1958) in a bargain bin at Barnes & Noble shortly after my encounter with the UFO art. Jung postulated that regardless if flying saucers actually exist, people have reported seeing them throughout history—with a particular spate of sightings during the Cold War—because they seek an image of wholeness in times of social and spiritual rupture. The flying saucer's shape is—beyond that of a comforting breast or a protective womb— a mandala, a timeless and universal image of opposing forces converging. Perhaps Jung's concept of the collective unconscious needs to be reevaluated to account for the extent to which movies, TV and computers have superceded the function of dreams: Initially film served to reflect and make visible our innermost fears and desires. Now, the electronic media are projecting and implanting new archetypes in the collective psyche with a success rate that makes it impossible to guess at this time whether the chicken preceded the egg or vice-versa.

In the midst of widespread museum mega-surveys of the 20th century, The UFO Show began as a desire to address the new millennium in a lighthearted yet symbolic way. If there was one image that seemed to me to embody the wondrous intersection of the past and the future—or "future primeval"— it was the flying saucer. Late-night college screenings of 50s films like the sci-fi quasi-biblical classic *The Day the Earth Stood Still* left an indelible impression on me in the early 70s. Ten years later, I was equally entranced by the telegraphic expediency of Keith Haring's subway drawings with sombrero-like flying saucers zapping animals, pyramids and people alike, investing them with strange powers.

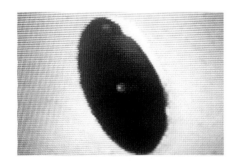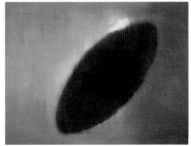

Claire Jervert, 4/1998oz-1. Cibachrome print on honeycomb aluminum, 1998. Courtesy Steffany Martz Gallery, New York.
Joy Garnett, Scud. Oil on canvas, 1996. Courtesy the artist and Debs & Co., New York.
Oliver Wasow, Untitled #169 (detail). Iris print, 1986. Courtesy Janet Borden Gallery, New York.

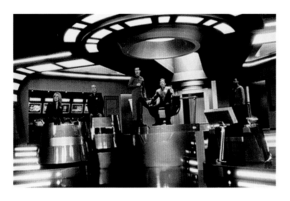

Still from **Galaxy Quest**, 1999.

But what this project really comes down to is the question of belief and the absence of absolute truth in the postmodern era. Given that the two main image banks for UFOs are either Hollywood stage sets involving elaborately constructed models, or widely circulated "documentary" shots by photographers like Billy Meier and George Adamski, we are dealing with a concept that—at least for those who haven't yet seen a saucer—exists purely on film. It's a modernization of the Shroud of Turin proving Christ's existence, only this time around the sacred artifacts are not imprints of blood on cloth, but light captured on emulsion. Today, about as many people believe in Christ as those who believe in flying saucers. Political candidates flaunting their family values pander to the former as reasonable law-abiding citizens, while the latter are dismissed as nuts.

In a parallel vein of reality-seeking, the recent sci-fi spoof *Galaxy Quest* has as its premise a childlike but techno-advanced band of extraterrestrials who have modelled their spacecraft and behavior on broadcasts of a Star Trek-type TV show they mistook for "historical documents." They transport the show's actors from a Trekkie convention to their starship, and the aging and disillusioned crew save the day by "believing in themselves," emulating their characters' strategies and bravery, operating "real" ship equipment designed after mere studio props. And of course what we, the viewers, are looking at are fancy but inoperative instrument panels representing ones that really work but are in turn based on props.

The flying saucer is the contemporary manifestation of the halo—a radiant circle indicating the presence of supernatural beings. With drawings, paintings, prints, sculptures, video and essays relating to discs, saucers and other phenomena associated with UFOs, the artists and writers in The UFO Show variously confront an historically ingrained and commercially reinforced locus of millennial obsession.

Left: George Adamski photo of a "Venusian mother ship and smaller scout vessels."
Right: Billy Meier website image.
(See plates on pages 46 and 92)

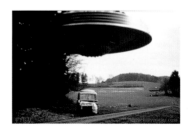

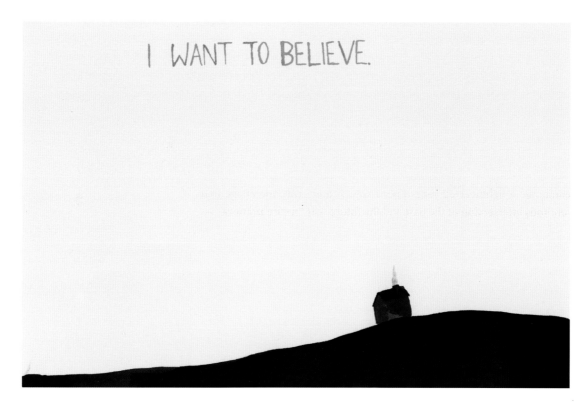

Amy Wilson, I Want to Believe. Ink and gouache on paper, 1999. Courtesy the artist.

A History Of Ufology: Notes Towards *Saucer Wisdom*
Rudy Rucker

Throughout history people have reported seeing unusual things in the sky: moving lights at night, odd shapes in the daytime. These heavenly portents were generally taken to be signs put there by God or the gods. Occasionally there was some suspicion that odd things seen in the sky were caused by human sorcerers, for instance witches on broomsticks. But at no time did people think of attributing the celestial anomalies to interplanetary travelers. For most of human history people did not commonly think of there being life on any heavenly body other than Earth.

One of the most famous early "UFO sightings" is known as Ezekiel's Wheel. It's enshrined in popular culture via the African-American spiritual that goes, "Ezekiel saw a wheel." The Nation of Islam leader Louis Farrakhan himself has spoken of wheel-shaped UFOs and a "Mother-Wheel." [Peebles 1994, p, 290]

Until I recently read Chapter 1 of the Old Testament Book of Ezekiel, I'd always had the impression that the prophet Ezekiel wrote about a single flaming wheel which hovered above him like a flying saucer. But in fact Ezekiel describes four creatures flying in a square formation, with each creature reaching out a wing on either side to touch the wings of its nearest neighbors. The fabled wheels seem to be attached to the bases of the creatures. The wheels gleam, they look like a wheel within a wheel, they have rims and spokes, "their rims were full of eyes round about," and they move about strictly as if connected to the creatures. Arching over the heads of the creatures is a crystalline dome upon which rests a throne bearing a humanoid form, who tells Ezekiel to go and tell the Israelites to pay more attention to God—or else!

Figure 1: Ezekiel's "father-ship."

In his stimulating survey of UFOs, *Anatomy Of A Phenomenon*, the French ufologist Jacques Vallee suggests that the creatures-and-wheels assemblage was a machine (perhaps the wheels are the nozzles of saucer-drive engines?) and goes so far as to speak of "the Ezekiel incident" as being a "detailed account of a landing." [Vallee 1965. p. 29] But, when you look at text in the context of other biblical writings, Ezekiel's report seems to be just another prophet's bombastic rant, unlikely to have had any foundation in physical fact.

There are any number of other historical UFO reports. In his book *Flying Saucers*, C. G. Jung cites two interesting examples of people seeing UFOs: in Nuremberg in 1561, and in Basel in 1566. These

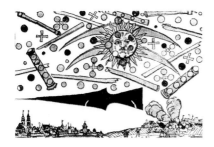

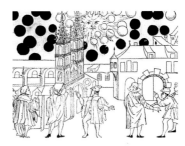

Figures 2 and 3:
Left: Nuremberg Broadsheet, 1561.
Right: Basel Broadsheet, 1566.

events were recorded in "broadsheets" of the time, a broadsheet being something akin to a one-shot newspaper.

According to the Nuremberg broadsheet, a number of men and women at sunrise on April 14, 1561, saw red, blue and black globes and disks flocking together in the sky near the rising sun. Some of the shapes seemed to arrange themselves in patterns such as rows and squares. In addition there were two great tubes within which more of the globes were to be seen. As Jung points out, the tubes are analogous to the notion of cylindrical motherships which carry the smaller flying saucers over greater distances.

The Basel broadsheet also reports a large number of globes moving about in the air; this time the globes are black, with some of them later turning red. In both cases the globes were thought to have been fighting with each other. Jung remarks that "if the UFOs were living organisms, one would think of a swarm of insects rising with the sun, not to fight one another but to mate and celebrate the marriage flight," and that "The militaristic interpretation is as characteristic of the sixteenth century as the technological one is of ours." [Jung 1958, p. 96]

In the November, 1896, a number of people near Sacramento, California, reported seeing a mysterious airship: a glowing gas bag in the sky driven by whirring propellers and equipped with a searchlight. Sightings of the "California Great Airship" spread across the country for the next six months.

In 1946 (which is the year in which, ahem, I was born) thousands of Swedish citizens spotted ghostly cigar-shaped objects in the sky; they were understandably concerned that they might be seeing German rockets. The ghost rockets sometimes seemed to explode, but no debris was ever found on the ground.

During the Second World War, bomber and fighter pilots from both sides reported seeing glowing objects that flew along next to their aircraft. There was no speculation at this time that the unidentified objects might be aliens. These lights were known as "foo fighters," either because (1) "foo" is a lot like the French word "feu" for "fire," or (2) because of the popularity of a comic strip called

10

Oliver Wasow, #164. Iris Print, 1987. Courtesy of the artist.

Smokey Stover about a slobbering, wacky, pun-spewing fireman who was fond of using the nonsense word "foo" in phrases like "Where there's foo there's fire!" [Cousineau 1995, p. 48], or (3) because "foo" is the sound of the first syllable of the then-popular military phrase "FUBAR," meaning "fucked-up beyond all recognition."

Around 1946, an eccentric dwarf science-fiction editor named Ray Palmer began pushing the notion of extraterrestrial visitors. Here's a characteristic quote from one of his editorials in his magazine, *Amazing Stories*:

Figure 4: **Foo fighters. Fortean Picture Library, Wales.**

If you don't think space ships visit the Earth regularly...then...your editor's own files are something you should see...And if you think responsible parties in world governments are ignorant of the fact of space ships visiting the Earth, you just don't think the way we do. [Peebles 1994, p. 6]

The modern concept of the flying saucer was born on June 24, 1947. A private pilot named Kenneth Arnold spotted some strange, darting objects in the sky near Mount Rainier. Here is the AP press report:

Pendleton, Oregon, June 25 (AP)—Nine bright saucer-like objects flying at 'incredible speed' at 10,000 feet altitude were reported here today by Kenneth Arnold, Boise Idaho, [a] pilot who said he could not hazard a guess as to what they were...Arnold said that he clocked and estimated their speed at 1,200 miles an hour. Arnold said they skipped along like saucers on water. [Peebles 1994, p. 9]

Two weeks later, another key event for ufology took place. On July 8, 1947, an officer in charge of public relations for an Army Air Force field near Roswell, New Mexico, reported that a crashed flying disk had been found. The next day the report was retracted, and the debris was said to be the remains of a weather balloon. Fifty years later, ufologists are still arguing about this, and the Roswell crash is something of an icon.

Freelance writer Douglas Keyhoe wrote an article, "The Flying Saucers Are Real," for the January 1950 *True* magazine. It was a very influential article, read and discussed by many. Keyhoe later expanded the article into a book of the same title. Keyhoe was the first ufologist to focus on the notion that the Air Force was carrying out a cover-up. He became the head of the National Committee For The Investigation of Aerial Phenomena (NICAP) in 1956, and carried on a relentless publicity war with the Air Force.

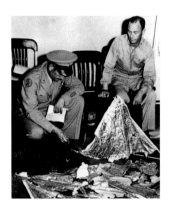

Figure 5: **Roswell crash debris, 1947.**

The Air Force did indeed start an investigation called Project Sign in December, 1947. This was followed by Project Grudge in 1949, and by Project Blue Book, which ran from 1951 till 1969. In addition the CIA convened the Robertson Panel in 1953, and the Air Force funded a big UFO study at the University of Colorado headed by the quantum physicist Edward Condon. The Condon Report came out in January, 1969. Broadly speaking, the studies concluded that most UFO sightings are explainable; that there is a residue of sightings that have not been satisfactorily explained; and that the UFO phenomenon poses no threat to national security.

The largest class of explainable UFO sightings is caused by people seeing the planets Venus and Jupiter low in the sky. The average person is so sadly out of touch with the natural world that even the most ordinary astronomical phenomena can seem like a big surprise. Other common causes of UFO sightings are clouds, airplanes, electric signs, and lightning. Less common are meteorites, electrical phenomena such as coronas around high-voltage power equipment, and auroral displays in the upper atmosphere. Still less common are such little-understood phenomena as ball lightning and piezoelectric plasma generation by shifting earthquake faults.

In 1951, *The Day The Earth Stood Still* came out. In this classic science-fiction movie, a saucer lands in Washington D.C., bearing an alien who has come to tell humankind to be peaceful. There was a feeling in those times that some extraterrestrial Earth-watchers might have noticed the nuclear explosions of the late 1940s. With the growing tension of the Cold War following upon the two World Wars, there was a hope that some higher power might bring peace to our planet.

In November, 1952, George Adamski, a sixty-year old freestyle Southern California philosopher and sometime short-order cook, said that he had met aliens. Adamski co-authored a book called *Flying Saucers Have Landed* and said that he himself had taken several rides on the saucers. He was the first of a wave of UFO contactees. Adamski and the other contactees taught that the "space brothers" had come to bring us peace and to bring us into closer contact with God.

In 1956, Gray Barker added a new twist in his book *They Knew Too Much About Flying Saucers*. He said that contactees were commonly visited by swarthy men in black suits who told them to keep quiet about what they knew. These Men In Black became an ongoing part of UFO lore. The Men In

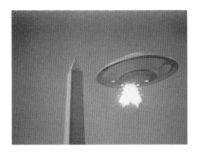 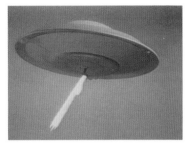 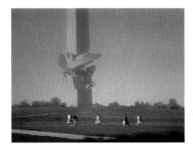

Video stills from Earth vs. the Flying Saucers [1956].

Black are believed to be opportunistic humans who have made a deal with the aliens to help cover up the aliens' activities. The humorous *Men In Black* movie of 1997 took off on this idea, complete with a memory-erasing device called a "neuralyzer."

In the mid-1950s there was a series of striking UFO sightings in France. The French ufologist Aime Michel published a book with some fascinating accounts of the sightings. Here's a lovely long quote from a French farmer describing what he saw on September 14, 1954:

> It was about five in the afternoon. Emerging from the thick layer that looked like a storm coming up, we saw a luminous blue-violet mist, of a regular shape something like a cigar or a carrot. Actually, the object came out of the layer of clouds in an almost horizontal position, slightly tilted toward the ground and pointing forward, like a submerging submarine.
>
> The luminous cloud appeared rigid. Whenever it moved, its movements had no connection with the movements of the clouds, and it moved all of a piece, as if it were actually some gigantic machine surrounded by mist. It came down rather fast from the ceiling of clouds to an altitude which we thought was perhaps a half-mile above us . . . the object was in a vertical position . . .

During this time the dark clouds went on scudding across the sky, dimly lighted from underneath by the violet luminosity of the object. It was an extraordinary sight, and we watched it intently. All over the countryside other farmers had also dropped their tools and were staring up at the sky like us.

All at once white smoke exactly like a vapor trail came from the lower end of the cloud . . . While the rear of the trail was dissolving in the air and being carried off by the wind, the source of the trail went up to the very top of the vertical object and then started to come down again Only then, after the smoke trail had vanished entirely, could we see the object that was sowing it—a little metallic disk, reflecting in its rapid movements flashes of light from the huge vertical object. The little disk . . . went down toward the ground again, this time moving away. For quite a few minutes we could see it flying low over the valley, darting here and there at great speed, sometimes speeding up, then stopping for a few seconds, then going on again, flying in every direction between villages that were four miles apart. Finally, when it was almost a mile from the vertical object, it made a dash toward it at headlong speed and disappeared like a shooting star into the lower part, where it had first come out. Perhaps a minute later the carrot leaned over as it began to move, accelerated and disappeared into the clouds in the distance. [Michel 1958, quoted in Vallee 1964, pp. 107-108]

The great carrot and the little disk above the villages! How charming, how French.

Back in the States, the 1956 movie, *Earth vs. the Flying Saucers* showed a full-on battle between the humans and the aliens. I myself remember seeing this one as a ten-year-old boy. Ed Wood's famously cheesy *Plan 9 From Outer Space* came out in 1959, complete with alien vampires and string-suspended pie pans for flying saucers. The comic *Mars Attacks* film of 1997 was a kind of reprise of these two golden-age SF movies.

In April, 1964, a police officer named Lonnie Zamora said that he saw a saucer in the sky near Socorro, New Mexico. The saucer landed, two aliens appeared—looking like "people in white coveralls"—and then the saucer took off again. Some of the brush was burned and indentations in the ground were found. These were the first example of what became known as pad prints.

In the late 1960s a number of people started reporting seeing UFOs near electrical power lines, and a popular notion was formed of saucers sucking power out of our grid. Some blamed the great East Coast blackout of 1967 on UFOs. Debunkers of the saucer and power line connection like to point

out that (a) the level of electrical wires is where one is most likely to see a bright planet such as Venus, and that (b) power lines sometimes have coronas. But there is something pleasing in the thought of a saucer refueling from a high-tension line. It's nice to think that we have something they need.

The most significant ufological event of 1967 was the appearance of John Fuller's book, *Interrupted Journey*. This tells the story of Betty and Barney Hill, a couple who under hypnosis had come to believe that they were abducted by aliens on September 19, 1961. Their experience was not a pleasant joy-ride such as the jaunts around the solar system which contactees such as Adamski described. The Hills' experience was the first example of the negative, psychosexual kind of alien contact experience. Betty said that aliens with big noses had undressed her, poked her with needles on wires, and had then stuck a needle into her navel. The *Interrupted Journey* also included a star map drawn by Betty; some ufologists believed that the map indicated that Betty's abductors came from Zeta 2 Reticuli, a double star system light-years away.

Let us note in passing that some of the other locations which ufologists have mentioned as homes of the aliens include the multiple star Alpha Centauri, 4.4 light-years from Earth, the Andromeda galaxy, 180 thousand light-years off, Arcturus, the fourth brightest star in the sky and 36 light-years away, the great stars Betelgeuse and Rigel in the Orion constellation, Sirius, the Dog Star, and the interior of our (putatively) Hollow Earth.

In September, 1967, a horse named Snippy was found with the skin and flesh gone from his head, and his owners formed the idea that Snippy had been deliberately mutilated, perhaps by aliens. This was the first report in a wave of livestock mutilation reports which peaked in the 1970s. Some cattle mutilation accounts claim that the mysteriously butchered cows have legs which are broken as if the cattle had been dropped from a great height (i.e. from a satiated saucer). Like the notion of saucers near power lines, the concept of cattle-mutilating aliens took a deep hold on the public consciousness. Again there is this pleasant notion of the supernal saucers having some of the same needs as humans.

In the 1970s, C. G. Jung's UFO writings of 1958 achieved a wide level of recognition and popularity. Jung's position is a subtle one. (a) He feels that some odd things are definitely being seen. (b) He feels that the meanings we ascribe the to UFOs are projections of our psychic needs. (c) He adds this Jungian fillip: there is a cosmic synchronistic connection between the appearance of the UFOs and mankind's needs as the Christian era comes to an end. Here are two quotes (with my letter labels inserted) that capture Jung's position:

> (a) . . . even if the UFOs are physically real, (b) the corresponding psychic projections are not actually caused, but are only occasioned by them. Mythical statements

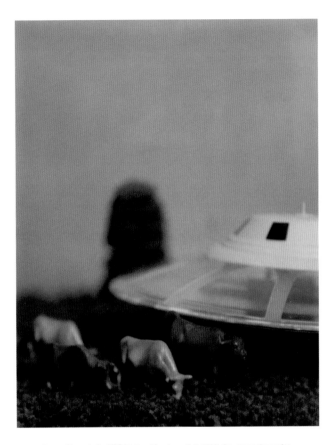

of this kind have always occurred whether UfOs exist or not. These statements depend in the first place on the peculiar nature of the psychic background—the collective unconscious—and for this reason have always been projected in some form. (c) This particular projection, together with its psychological context—the rumor — is specific of our age and highly characteristic of it. The dominating idea of a mediator and god who became man, after having thrust the old polytheistic beliefs into the background, is now in its turn on the point of evaporating. [Jung 1958, pp. 107-108]

(a) UFOs are real material phenomena of an unknown nature . . . which perhaps have long been visible to mankind, but otherwise have no recognizable connection with earth or its inhabitants. (b) In recent times . . . unconscious contents have projected themselves on these inexplicable heavenly phenomena and given them a significance they in no way deserve. (c) Since they seem to have appeared more frequently after the second World War than before, it may be that they are synchronistic phenomena or 'meaningful coincidences.' The psychic situation of mankind and the Ufo phenomena as a physical reality bear no recognizable causal relation to one another, but they seem to coincide in a meaningful manner. The meaningful connection is the product on the one hand of the projection and on the other of round and cylindrical forms which embody the projected meaning and have always symbolized the union of opposites. [Jung 1958, pp. 110-111]

Jung explicitly suggests that the UFO myth may in fact be replacing the old myth of Christianity. (I use "myth" here not in the sense of "fable" but in the sense of "meaningful belief system.") For

Jung, the UFO phenomena are "changes in the constellation of psychic dominants, of the archetypes, or 'gods' as they used to be called, which bring about, or accompany, long-lasting transformations of the collective psyche." [Jung 1958, p. 5]

A good fictional representation of Jung's viewpoint appears in Ian Watson's 1978 science-fiction novel, *Miracle Visitors*. Jung's influence can also be found in the prominent ufologist Jacques Vallee, who was the model for the French ufologist in *Close Encounters of The Third Kind*. In a recent book, Vallee makes an intriguing remark about UFOs:

> The simple truth is this: if there is a form of life and consciousness that operates on properties of space-time we have not yet discovered, then it does not have to be extraterrestrial. It could come from any place and any time, even from our own environment The entities could be multidimensional beyond space-time itself. They could even be fractal beings. The earth could be their home port. [Vallee 1991, p. 255]

In 1999, I published a book called *Saucer Wisdom* about my conversations with a UFO contactee named Frank Shook. According to what Frank told me, Vallee is partly right. The aliens are indeed from a paratime which lies beyond ordinary space-time. And I would imagine that the information compression involved in their personality wave encryption is of a partially fractal nature. In addition, some saucerians are in fact from the Earth's own future. But the vast majority of them are from distant regions of the universe.

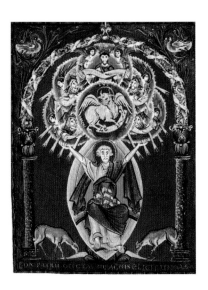

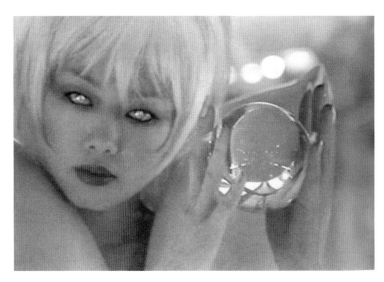

Left: St. Luke from the Gospel Book of Otto III. Circa 1000.

Right: Mariko Mori, Miko No Inori. Video, 1996. Courtesy Gallery Koyanagi, Tokyo and Deitch Projects, New York.

Going back to our historical timeline, a TV movie called *The UFO Incident*, based on the abduction stories of Betty and Barney Hill account was shown on October 20, 1975. This film was of key historical significance, as it was the first time that aliens were depicted in the canonical modern way: as short, gray-skinned, hairless, and with big, almond-shaped eyes. The excellent 1977 Steven Spielberg film clinched this image of the aliens. In the 1980s ufologists began referring to these kinds of aliens as Grays.

Grays are always depicted as about the size of children, thin and spindly, with big bald heads and enormous slanting eyes. Their noses, ears and mouths are rudimentary. It is as if they think and see, but do not taste, smell, speak, or listen. They look like creatures ideally evolved for watching—which is perhaps not too far wrong, although it is certainly fallacious to imagine the saucer aliens as actual flesh-and-blood humanoids. The slanted-eye alien image has become so pervasive that it is hard to really grasp that the icon is only some twenty years old.

Regarding the title of the Spielberg movie, a close encounter of the first kind is the sighting of a UFO that is near enough to you so that you can make it out as a detailed object. This is as opposed to seeing lights or flashes in the sky.

A close encounter of the second kind involves finding or experiencing some physical evidence of the UFOs. Evidence might include burnt vegetation or pad prints on the ground, the sudden stopping of electrical machinery (such as your car's ignition), or a strange sunburn. Showing up with odd parts of your body burnt bright red is a tried and true way to get attention at a UFO conference.

Left to right: John Brill
Material Image AH71151
Material Image AG38531
Material Image BH00100
Material Image SR09041
Material Image AH71552
All selenium-toned silver prints, 1991.
Courtesy Kent Gallery, New York.

A close encounter of the third kind involves seeing the aliens themselves. Since the 1970s, the Center For UFO Studies has extended the classification schema to include close encounters of the fourth kind: these are the abduction experiences. I think it might make sense to speak of Frank Shook's experiences as close encounters of a fifth kind. He gets aboard the saucers, but rather than being treated like some masochistic lab-rat abductee, he is used as a kind of guide through Earth's time.

Figure 5: Gways wuv oo!
yeah, yeah, yeah.

As the 1970s wore into the 1980s, people all but stopped reporting seeing UFOs. The most common UFO reports became the filthy abduction tales. This trend was marked in 1981 by the first big book on abductions, *Missing Time* by Budd Hopkins. Hopkins suggested that aliens needed sperm and ova from humans, perhaps for breeding experiments. The abduction experiences he describes are cold, clinical rape. To make things worse, the abductees commonly believe that the aliens had put implants into them so as to be able to control them. This is of course a standard schizophrenic delusion.

Keep in mind that most abductees only remember their experiences under hypnosis, and that these alleged experiences are to have happened while they were asleep. Abductees' accounts are, in other words, hypnotically induced memories of dreams. Nevertheless, Frank says that a small number of these accounts are true. He somewhat heatedly argues that the rubber-gloves dreariness of the abductees' accounts is a result of neuroses among the abductees—rather than being a result of cruelty on the part of the aliens. Frank says

Above: Christopher Johnson, Rt. 97, Oregon (Mt. Shasta). Oil on linen, 1997. Courtesy the artist.
Left: Christopher Johnson, Three Rivers, New Mexico. Oil on linen, 1997. Courtesy the artist.

20

that the aliens' basic stance is to do whatever their human passengers expect. Sadly, many people expect to have their genitals painfully manipulated and their rectums probed.

Another trend which has increased greatly in the 1980s and 1990s is the obsession with the crashed saucer stories. Book after book about the wretched Roswell weather balloon appears, and it is an article of faith to many that the U.S. Government has saucers and aliens in its possession. The concern with government involvement was greatly fostered by a man named William Moore. In the mid-1980s, Moore publicized two amateurishly forged government documents called Project Aquarius and Majestic-12. These documents claim that dozens of saucer crashes occurred in the early 1950s, and that saucers with live aliens were indeed recovered by the Air Force. A high-level government cabal of twelve men, known as the Majestic 12 (or MJ-12 for short) group, was allegedly set up by President Truman after the first crash at Roswell to deal with the situation.

In the early 1990s, some fringe-thinkers began claiming the U.S. Government and MJ-12 had sold out the humans to the aliens. According to them, human abductions and cattle mutilations are covered up in exchange for alien technology, and a secret base for the aliens has been built at a secret

military test site north of Las Vegas named Groom Lake, a.k.a. Area 51, a.k.a. Dreamland. The modern power-obsessed ufology exudes a trapped, hopeless feeling of impotence. A literate and oddly humorous presentation of these ideas can be found in John Shirley's 1996 science fiction novel *Silicon Embrace*.

In 1995, Curtis Peebles published a fascinating history of ufology called *Watch the Skies! A Chronicle of the Flying Saucer Myth*. I'd like to acknowledge here that I leaned heavily on the Peebles book in preparing my own brief survey. Looking towards the future, Peebles makes these remarks:

> The overriding factor in the future development of the flying saucer and alien myths is the impending turn of the century. Traditionally, these are times when there are popular expectations of great changes in society. As this is also the turn of the millennium, there are sure to be predictions of the end of the world and the Second Coming. Given the current attitudes, such thinking is sure to move the mythology in a darker direction...Finally, as the belief system becomes more akin to outright paranoia, one might expect talk about a cosmic unity between humans, God, and the aliens, if only as an escape from the ever darker alien myth. [Peebles 1995, p. 290]

Some of this came depressingly true in March, 1997, when the Heaven's Gate cult persuaded 39 members to commit suicide in the expectation that their personalities might be taken aboard a mother ship supposedly trailing the Hale-Bopp comet.

In this context, I would like to stress that although, according to Frank Shook, the aliens are indeed capable of transmitting themselves as personality waves, it would be impossible for a person to accomplish this with our current "pre-femto" technology.

The aliens wish neither to enslave us, nor to lure us into a premature death. They are here simply to enjoy watching our frantic antics—to smile and muse over us, and perhaps even to laugh.

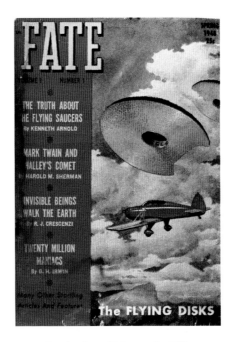

Premiere issue of Fate magazine, 1948.

Sources Cited

[Cousineau 1995] Phil Cousineau, *UFOs: A Manual For The Millennium,* Harper Collins 1995.

[Hopkins 1981] Budd Hopkins, *Missing Time*, Ballantine Books 1981.

[Jung 1958] C. G. Jung, *Flying Saucers: A Modern Myth of Things Seen in the Skies*, Princeton University Press 1978, (Originally published in 1958).

[Keyhoe] Donald Keyhoe, *The Flying Saucers Are Real*, Fawcett Publications 1950.

[Adamski-Leslie 1953] Desmond Leslie and George Adamski, *Flying Saucers Have Landed*, British Book Center 1953.

[Mack 1994] John E. Mack, *Abduction: Human Encounters With Aliens*, Scribners 1994.

[Michel 1958] Aime Michel, *Flying Saucers And The Straight-Line Mystery*, Criterion Books 1958.

[Peebles 1994] Curtis Peebles, *Watch The Skies! A Chronicle Of The Flying Saucer Myth*, Smithsonian Institution Press 1994.

[Randle-Schmitt 1994] Kevin Randle and Donald Schmitt, *The Truth About The UFO Crash At Roswell*, M. Evans & Co. 1994.

[Rucker 1999] *Saucer Wisdom*, Tor Books 1999.

[Shirley 1996] John Shirley, *Silicon Embrace*, Mark Ziesing Books 1996.

[Strieber 1988] Whitley Strieber, *Communion: A True Story*, William Morrow, 1988.

[Vallee 1965] Jacques Vallee, *Anatomy of a Phenomenon*, Henry Regnery Co. 1965.

[Vallee 1991] Jacques Vallee, *Revelations: Alien Contact and Human Deception*, Ballantine Books, 1991.

[Watson 1978] Ian Watson, *Miracle Visitors*, Ace Books 1978.

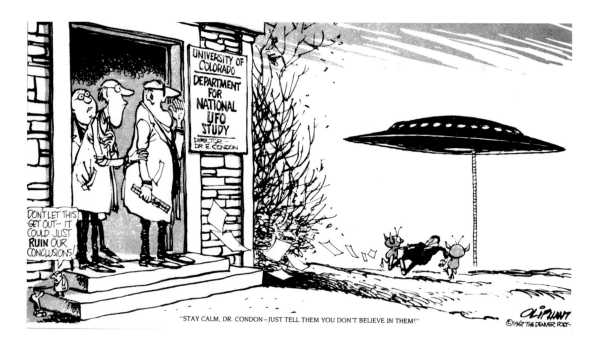

"Oliphant" comic © 1967 The Denver Post

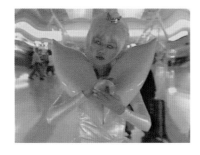

Mariko Mori, Miko No Inori. Video, 1996. Courtesy Gallery Koyanagi, Tokyo, and Deitch Projects, New York.

Disco Volante
Paul Laffoley

I saw my first "foreign film" in 1951. It was not playing at The Telepix, The Translux or The Brattle Theatre, but at Boston's widest screen of the day—The RKO Keith Memorial Theatre on Tremont Street, halfway between Park and Boylston. The director was not Vittorio De Sica, Fritz Lang, Jean Cocteau, or Ingmar Bergman, but an American, Robert Wise, a Virgo born on September 10, 1914. What I am referring to is the classic flying saucer movie of the atomic age, *The Day the Earth Stood Still*, direct from the film studios of 20th Century Fox.

Having been regaled since 1947 by stories of riding in flying saucers by the man who came to cut our bushes at my family home in Belmont Massachusetts (he had been a recent emigrant from Belmonte, a small town in Italy near Naples), I was uniquely prepared to see this visionary and truly foreign film. Our gardener spoke of how he and his autistic son had been lifted by beams of light into a "disco volante" (Italian for flying saucer or disk), and then shown new devices, new worlds, and glowing people hundreds of Earth years old. He claimed seventeen rides in all. The "people" gave him the symbol of "The Order of Melchizedek," showing to the rest of Earth that one is worthy to aid in the development of the "The Cosmic Task." On the day he left for good, with trembling hand outstretched, he offered me the medallion. Seeing it safely in my grip, he extended a forefinger to my brow and uttered in broken English: "For the sake of the Almighty Spirit, astound this world." What he handed me was a coin-like object slightly larger in diameter than 2 7/16" and a fraction over 3/32" in thickness. Each side bore the image of a Mogen-David with a Swastika inside it, only with the opposite orientation. When I held the dark green medallion in my hand, it seemed to be composed of the lightest metal I have ever felt.

At mid-century, there were basically three major film genres: (1) Hollywood—the world is a light, bubbly, colorful fairy tale; (2) Slavic Despair—life is the shards remaining after the spectacular but necessarily tragic battle between free will and fate; and (3) Foreign (origin Western Europe)—life is in exceedingly bad taste, but by means of grace, charm and wit, in the end we will outclass reality itself. Robert Wise chose the Foreign genre within which to couch his film because he was delivering a barbed message to an ideologically divided world beset with sentimentality but lacking humor. He was saying what people knew but were afraid to admit: the Cold War could suddenly become very hot, ending in an atomic holocaust. The Hollywood genre would be too optimistic, the Slavic Despair too hopeless. In choosing the Foreign genre, he rode the high ground between aristocratic distancing and the pop culture of his day, keeping the tension alive.

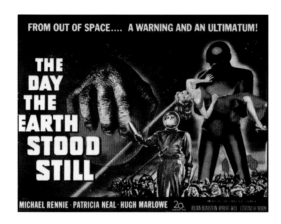

The Day the Earth Stood Still movie poster [1951].

The Day the Earth Stood Still has all the earmarks of the Foreign film, particularly its sub-genre, the Film Noir: black-and-white high contrast photography, creating malevolent shadows accompanied by the foreboding background music by Bernard Herrmann and augmented by the otherworldly sounds of the Theremin—the first electronic instrument. The plot is structured in cinema verité to convey candid or newsreel realism. There are scene cuts from Calcutta, Moscow, Paris, London, a pool room, a gas station, an amusement park, a draw bridge, and, of course, many scenes from downtown Washington D.C. Mock tabloids fill the screen with descriptions of "Spacemen From Mars." Prominent radio and TV reporters of the day appear in cameo, playing themselves: Elmer Davis and Drew Pearson—who never took his hat off after age 35—spit staccato warnings, and H.B. Carltonborn's "there's good news tonight"optimism is offset by Gabriel Heater's blithering paranoia.

In the eyes of a mid-century European, American culture was populated with the hopelessly monolingual and the artistically inferior. Wise, knowing that America no longer conformed to the image held by most Europeans that we are a naive world whose culture is exemplified by the Western or the Jerry Lewis movie, took the language theories of the Austrian philosopher Ludwig Wittgenstein (1889-1951) to heart. He directed a Foreign film without subtitles. We hear English spoken (both Posh and Cockney), American (Midwestern and New England), Hindi, French, Russian, and, of course, the language of Klaatu: Aporue. Also, according to Harry Bates, author of the story, Klaatu's home "planet" was Europa, one of the four largest moons of Jupiter, one-fourth the diameter of the Earth—smooth and icy, containing water. Klaatu, therefore, is a "Cosmic European."

Wittgenstein claimed that no language can really be translated. There are only "family resemblances" of meaning, and no private languages either. Language is a game, therefore, which is known only by inventing a new language. The intellectual bewitchment of the "untranslatable" is over, and the world according to Wise is seen as truly international. In fact, he realized that the U.S. was becoming the entertainment capital of the world. America was willing to be the audience for the rest of the world and itself, as our view that reality is divided between the subjective and the objective began to blur and fade out.

25

Klaatu's language is an imagined variation on Medieval Scientific Latin (circa 1238-1368 A.D.), which has an almost English word order. For example, in the beginning of the movie when soldiers shoot Klaatu in the arm, his robot Gort begins to use his all-powerful weapon upon all the Earth weapons in sight. Klaatu shouts: "Gort Declato Brosco." Everyone in the audience knows he means "Gort, stop using your death-ray." Or, at the finale, when Klaatu has just delivered his lecture to the intellectuals of the world (the "I Am Leaving Now" speech) on how "the universe is growing smaller every day," and how the Earth threatens the established peace of the planetary system (the cosmic urbanism) and must choose to either get with the system or be eliminated, he says "Gort Baringa." They turn heel in military fashion (Klaatu is in his black spacesuit) and enter the flying saucer. You know by context that the phrase means "Gort, let's move it." The gathered throng watches stunned as the ship rises easily into the evening sky, passing swiftly into the oblivion of outer space.

In mid-film, at his first opportunity (Sunday, April 13), Klaatu enters his ship furtively, having "awakened" Gort a minute before by means of a flashlight signal, so that he could dispatch the two soldiers guarding the premises. Now inside the ship, Klaatu turns on "the interrossitor" (the ship's communication device with the home planet) by simply waving his hand in the air, Theremin-style, near the controls. He says "Emray Klaatu naruat macro proval brarato lukto denso implikit yavo tarri axell plakatio baringa degas." From the preceding action, the translation is obvious: "Klaatu reporting, there will have to be a slight change of plans dealing with this crude and tasteless planet. The people are beset with fear and stupidity, but I am confident I can handle the situation. Be home soon."

Several days before this in the late afternoon (April 10), the injured Klaatu is brought under heavy guard to Walter Reed Hospital and placed in room 306. Immediately, his convalescence is interrupted by a knock on the door—it is Mr. Harley, Secretary to the President of the United States. Mr. Harley wants to know why Mr. Klaatu ("just Klaatu,"replies the alien) came to Earth. Klaatu responds that his mission is of utmost importance, but he will not talk to any one person or nation. Instead, he requests a meeting of all the chiefs of state, since Mr. Harley claims the United Nations does not represent all nations of the world. Harley returns the next day with news that it is both ideologically unprecedented and geographically impractical to have the meeting in Lafayette Park, directly behind the White House. This is where Klaatu landed his ship, right between two baseball diamonds, perhaps thinking they were existing "crop circles." An annoyed Klaatu responds with: "It took five of your months to get here, traveling 250 million of your miles," but then his mood softens as he looks out the window at ordinary people meandering about. "Perhaps before making any rash decisions (like asking Gort to reduce the Earth to a mere cinder) I should go out among the common people in order to discover the basis of their unreasoning attitudes." Harley warns him not to do this but Klaatu escapes and for a while eludes the military police to assume his guise as an Earthman called Mr. Carpenter. (Before leaving the hospital, he steals the belongings of a Major Leon Michael Carpenter, due to be released from Walter Reed on July 18.)

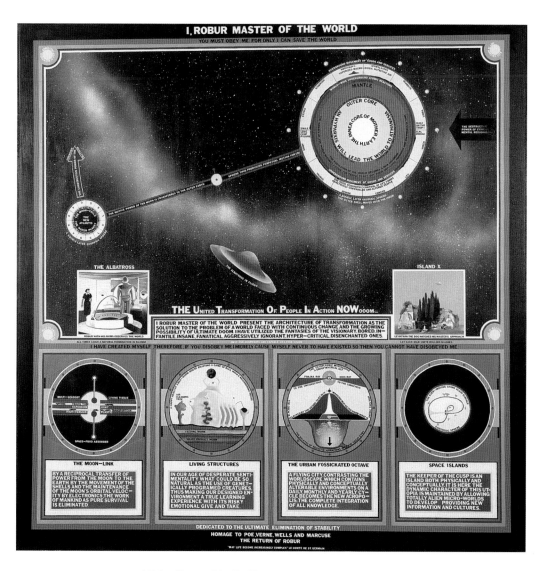

Paul Laffoley, **I, Robur Master of the World**. Oil on canvas, 1967. Courtesy Kent Gallery, New York.

Near the climax of the action, Klaatu delivers his most famous line in his native tongue, the phrase everyone knows by heart: "Gort Klaatu Barada Nikto." Because of the circumstances surrounding the absolute necessity of these words being said to Gort by widow Helen Benson (played by Patricia Neal, who is a brunette in the movie and looks and acts like Donna Reed with permanent P.M.S.), an exact translation is impossible. Klaatu is instructing her to say the phonemes correctly as they ride together in the back seat of a cab. He has reached a point of desperation and isn't interested in giving her a foreign language lesson.

Klaatu first meets Helen when he rents a room in the same boarding house where she and her young son, Bobby, live. In fact, he ends up in the room next to hers. The town house is at 1412 Harvard Street North West—in the fashionable Georgetown section of the city, right off Massachusetts Avenue. It is Bobby, played by Billy Grey, who discovers that Klaatu has no "Earth money"—he brought only per-

Paul Laffoley and The Urban Fossickated Octave. Oil, acrylic, ink, and lettering on canvas, 1968. Private collection, New York.

fect diamonds ("they are easy to carry and they don't wear out") as money. He cannot exchange them without revealing his true identity. He does, however, take two dollar bills from Bobby in exchange for two diamonds ("I want to take you to the movies"). Klaatu, for the few days he lives incognito at Mrs. Crockette's (played by Frances Bavier) rooming house, lives like a homeless person on the charity of others. Apparently this is fine with Mrs. Crockette, a middle aged widow who is agog with pride and possessiveness when she realizes that "Mr. Carpenter" wants to stay. His tall, handsome appearance and aristocratic demeanor, plus his use of language (Mrs. Crockette believes from his accent that he comes from a location a long way from Washington D.C., that is, New England!) convinces her that he outclasses all the rest of her boring boarders. Not once does she suspect who or what he really is.

Klaatu is played by Michael Rennie, who, as a British repertory actor, puts on a performance that makes the rest of the cast look like soap-opera regulars, walk-ons, or just rank amateurs. This contrast is what gives Klaatu his otherworldly ambiance. Robert Wise, of course, planned this carefully. He presented Klaatu as a role model for human evolution: physically, intellectually, morally, and culturally superior to Earthlings. He comes from a planet that has no wars ("gee . . . that's a good idea," says Bobby). But as the "Earthman" Mr. Carpenter, he is shown stealing, mooching, littering, moving about in disguise, lying to children, making technical errors (he claims to be staying in room 309 at Walter Reed when the number on the door is 306). To top it off, he offers the Earth an Hobson's Choice: either the Earth accepts the system of peace loving planets or it will be eliminated. But aside from these Earth-like imperfections, Wise moulds the character of Klaatu in direct contrast to the images of aliens most audiences are familiar with—warmongering, bloodthirsty, slimy mutants ("with square heads, three big

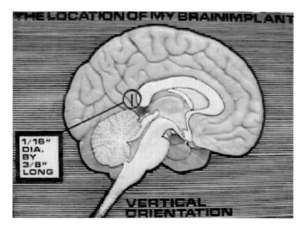

Paul Laffoley, Thanaton (detail). Ink, lettering acrylic on board, 1996. Collection Peter Giblin.

eyes and tentacles") bent on non-negotiable carnage and dedicated to the ultimate obliteration of all human life, and, of course, all depicted within architectural movie environments of eye-drugging fantasies of destruction, bolting action, bleeding color, special effects and monster budgets. Neither the images of aliens from the *Buck Rogers* or *Flash Gordon* serials of the 1930's, nor those depicted as soon as two years after the making of *The Day the Earth Stood Still*—as in Byron Haskins' rendition of H.G. Wells' *The War of the Worlds*—ever went off tradition as the image of Klaatu did.

Even the recent blockbuster *Independence Day*, awash in sentimentality, special effects, and pumped up politically-correct patriotism, cannot come close to subsuming the brilliance and originality of what

Wise accomplished. *Independence Day*, which contains film clips on a TV of *The Day the Earth Stood Still*, has its flying saucer imitating the flight path of the Thanaton (Klaatu's ship). Proceeding from "Moon Base Alpha," the manhole-cover-from-hell that heads toward Washington D.C., it goes right over the Capitol Building, then follows the Mall, takes a right at the Washington Monument, passes over the ellipse and its zero milestone (the polar axis of political power in the world), and finally hovers in space over a 15-mile diameter of the U.S. Territory, awaiting instructions from the mother-ship to blow up the White House. Klaatu and the Thanaton simply *landed*.

The script of *Independence Day*, loaded with references from everything from *Star Wars* to *Jurassic Park*, is in reality a remake of *The War of the Worlds* by H. G. Wells. A "virus" gets the aliens in the end in both venues. This pastiche of set and plot is not even science fiction. It is an extravaganza like the lavish musicals mounted in the 1940s to give audiences weary from World War II a moment of diversion. Today, it is "terrorwar" and street crime which are targets for constructs of distraction.

Then again, *The Day the Earth Stood Still* is not really science fiction either. Nor is it an example of horror or fantasy. Hugo Gersback, in the inaugural issue of *Amazing Stories* in 1926, defined the literary genre of science fiction "as a type of story—a charming romance intermingled with scientific fact and prophetic vision" that began with the works of Edgar Allan Poe (1809-1849). As a young director, Wise sensed the end was near for science fiction when he observed the academic literati scouring the potboiler pulp fiction shops for the plot of their next tome. In 1961, Robert Heinlein (1907-1988) essentially killed off science fiction with his seminal book *Stranger in a Strange Land*, a set of instructions for the sixth incarnation of "The New Age" (the 1960s). From then on, science fiction became ad-hoc research and development for whomever cared to avail themselves of the ideas put forth. NASA used the *Star Trek* TV series for programming directives and inspiration. Finally, at exactly 10:56 PM EDT on July 20, 1969, Neil Armstrong's foot first touched the Moon's surface, closing the lid of science fiction's coffin forever.

The Day the Earth Stood Still was cast in the present, as Wise was intent on showing that Klaatu's world was possible to the Earthlings of 1951, their present. Like people entering a time machine for the first time, all sense of history and futurology vanish as the unexpected richness of the present moment is encountered. Klaatu comes from a race of humanoids at once older yet more biologically, culturally, intellectually, technologically, and morally advanced than us, but this race exists now. He is youthful in appearance while being 78 years old ("life expectancy is 130"). A flesh wound from an Earth bullet is healed overnight by means of some salve he brought with him, yet he is as vulnerable to nature as we are. He is not like the comic book character Superman, who is a biological freak in our environment. When shot a second time, Klaatu dies, but aided by Gort—a cyclopean wonder of technology with absolute power to decide who lives or dies—he is brought back to life by a device on board

his ship that "under certain circumstances will restore life for a limited period of time." (Lock Martin, almost seven feet tall, was working as a doorman at Sid Grauman's Chinese Theater on Hollywood Boulevard when Wise cast him as Gort.)

When Professor Jacob Barnhardt (an Einstein-like character played by Sam Jaffe) asks Klaatu, who has revealed his true identity to the professor, to provide "just a little demonstration" of his power to call widespread attention to the seriousness of his mission, Klaatu begins fingering the professor's pipe and replies "Would the day after tomorrow be all right?" We are about the witness the implications of a technology that is beyond human belief.

It is Sunday evening, April 13th, and Klaatu has just shown "the smartest scientist on Earth" the solution to a problem in celestial mechanics that the professor had been working on "for weeks." Together, in Barnhardt's study, Klaatu is like a visiting luminary from the Smithsonian Astrophysical Observatory at Harvard, and Barnhardt becomes an aging Woody Allen who looks like he traded in his sense of humor for a degree from M.I.T.

At noon on the 15th, Klaatu effects "a brilliant idea that no one would have thought of:" From 12:00 noon until 12:30, he neutralizes all electrical devices around the globe—with the exception of hospital equipment and airplanes in flight, etc.—thus bringing the entire world to a standstill. During this one half hour, Helen and Klaatu are trapped between floors in an elevator at the Secretary of Commerce Building where Helen works. It is here that Klaatu not only discloses his true identity to Helen, but also a more detailed explanation of his mission than he had revealed to Professor Bernhardt. She now understands the fateful consequences for the Earth's future that he poses. She also discovers exactly how "alien" he really is.

Wise had two world-class geniuses in mind when he was developing Klaatu's character with screenplay writer Edmund H. North: The first was Nikola Tesla (1856-1943), the Croatian-born American inventor and electrical engineer; and second, Professor Leon Theremin (Lev Sergyevich Teremin, 1896-1993), physicist and inventor of the world's first electronic instrument, the Thereminvox, in 1920 in the Soviet Union. Like Leonardo Da Vinci (1452-1519) before them, they did not "live in the future," while everyone else "lived in the past," but devoured the infinite possibilities that lay before them in the present.

By 1888, Tesla had perfected the alternating current motor. In 1898 he invented simultaneously both radio and the world's first robot—a Telautomaton Boat. His death ray was completed in 1914. An article about it was seen in the July 11, 1934 issue of *The New York Times* when Tesla was 78 (the age of Klaatu). Other hints about Tesla occur in the movie such as the habit of Tesla performing

mathematical functions by threes or powers of threes. Klaatu changes his hospital room 306 into 309—an increment of three, with both numbers divisible by three.

When Klaatu waves his hands in space in front of his ship's communication center in his disco volante, he is preparing to contact his home planet on another of Theremin's inventions, the Etherphone. While requesting a flashlight from Bobby Benson (the symbol of youthful openness and curiosity), Klaatu notices Bobby's electric train set and casually remarks about a train that does not need any tracks. In the late 1920s, Theremin proposed an electronic bridge for superhighways called The Lev (from the spelling of his first name in Russian and the first syllable of the English word "levitation"). The bridge would "float" the weight of a truck across a 50-foot gap in space, 22 feet above the crossroad supported only by an electromagnetic surface.

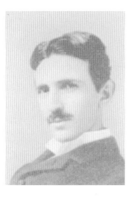

Left to right: Nikola Tesla, Klaatu, (Michael Rennie), and Leon Theremin.

The model for the device that enables Klaatu's temporary resurrection is the Vitatheremin, conceived of when a precious member of Theremin's New York circle of friends died unexpectedly in 1928. The device will revive a dead body within twelve hours of death by means of solenoids aimed at the body's chakras, which first are covered with liquid crystal paint. Liquid crystals have been known since 1891, and can indicate even the slightest electromagnetic activity in any corpse.

Tesla (Croatian but fully committed to America) and Theremin (the Earth-energy Russian but lukewarm Soviet spy) form the two halves of Klaatu's personality, which is:

Preternaturally young (both)

Mesmerizing (both)

Formal in manners (Theremin)

Aloof and romantically Platonic (Tesla—he was celibate his entire life)

Boundless in energy (neither slept much)

Focused and driven by a mission (both)

Eschewing the narrow, the self-serving, and the stupid (both were willing to examine all possibilities)

Klaatu's foil is Earthman Tom Stevens, the persistent and annoying suitor of the young widow Benson, (played by Hugh Marlow—star of popular TV series of the day called "I Led Three Lives," a drama about counter-espionage within an American Communist Cell). Tom is an insurance salesman, which places him pretty low on the food chain. He is suspicious ("I never did trust the guy"), avaricious ("why doesn't he have any money?" and "I'm down here at Bleeker's getting an appraisal of the diamond I found in his room"), traitorous ("get me General Cutler on the phone"), self-absorbed ("I don't care about the rest of the world!"), and hypocritical ("I think the guy's a crook"). Tom represents the dark side of America during its peak—the 1950s. He is in one character the embodiment of McCarthyism—indiscriminate allegations and public unsubstantiated charges toward one considered subversive.

"Doubting Thomas" fingers Klaatu to the Army authorities, which is the reason why we see Klaatu and Helen in the back seat of a yellow cab (license number H0012) as it speeds north on 14th Street from Harvard Street, headed, they believe, to the safety of Professor Barnhardt's office. This is the scene where Klaatu speaks the famous phrase to Helen. But "Plan B in Zone 5" closes in on them. Only a few blocks away from Barnhardt's, Klaatu and Helen panic and jump out of the cab. Klaatu makes a run for it but is shot down the street. Helen, leaning over Klaatu, hears what she thinks are his last words: "Get that message to Gort." His body is taken by the authorities to a police station across the street. Meanwhile, back at the ship, Gort, sensing Klaatu's death, melts the block of "K-L-9-3" he had been immobilized by, in time

Video stills from The Day the Earth Stood Still.

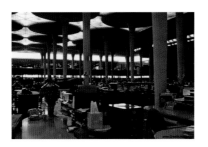
Interior of Johnson Wax Building by Frank Lloyd Wright.

to receive Helen and hear her say for the second time "Gort. Klaatu Barada Nikto." Now the meaning is clear: "Gort, I am dead, come get my body but don't destroy the Earth on the way over."

To me, the implications of *The Day the Earth Stood Still* for the Bauharoque period are legion in the film's exaggerated theatricality and utopian overtones, but it was not until July 4th, 1976, the publication date of *Unbuilt America: Forgotten Architecture in the United States from Thomas Jefferson to the Space Age* by Allison Sky and Michelle Stone that I realized why I like this movie so much—a movie I have seen over 873 times during the 49 years since it was first released. It is as much a part of architectural history as are the engravings of Giovanni Battista Piranesi (1729-1778) or the renderings of Étienne-Louis Boulée (1728-1799). "Unbuilt architecture" has somehow sustained itself against the for-

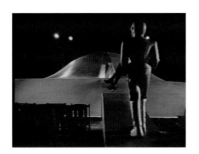 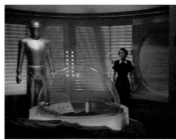 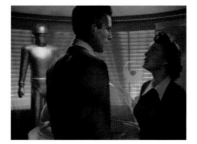

Video stills from **The Day the Earth Stood Still.**

tunes of fashion that have attempted to declare it irrelevant as opposed to the truly real "built architecture." In a sense, the movie was the first piece of collaborative architecture ever done by Frank Lloyd Wright (1867-1959). Wise contacted him in 1949 to work on the set design because the director knew of Wright's interest in flying saucers from drawings in progress using the flying saucer form. Both the Annunciation Greek Orthodox Church (built 1956) and the Sports Club for Huntington Hartford (unbuilt 1947) are examples of his use of this form.

Working with the set designers for the movie, Thomas Little and Claude Carpenter, Wright came up with the classic flying saucer profile: the soliton wave or curve of normal distribution. The interior of the ship was "lifted" right out of The Johnson Wax Company Administrative Headquarters that Wright had been working on since 1936. The horizontal translucent plastic tubing motif was a perfect foil for the

34

Bauhaus-like control instruments. The metal that sheathes both Gort and the Thanaton was, as Wright said at the time: "to imitate an experimental substance that I have heard about which acts like living tissue. If cut, the rift would appear to heal like a wound, leaving a continuous surface with no scar." The medallion I spoke of earlier must have been composed of this metal, as it felt very soft and flexible, yet returned to its original shape after any pressure on it was released. I wore it just once as a pendant in 1965 on my first visit to Paris when I was 25:

Sitting alone at a sidewalk table of the cafe "Les Deux Magots" on Boulevard Saint Germain, at the beginning of the summer, I order a Coke. The medallion hangs on the outside of my turtleneck, just for fun and to look cool. Suddenly a stranger—a young man about 19 or 20—sits down at my table. He is dressed like an Apache dancer, complete with beret and sunglasses. Before I can object he introduces himself in perfect English as Claude Vorilhon, a reporter with *Paris-Match* magazine. He says he wants

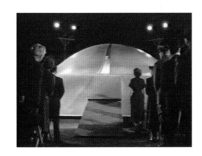

Video stills from The Day the Earth Stood Still.

to interview me. I say "Why?" He counters with "Well, you are an American in Paris." To which I reply "Isn't that the title of a Hollywood movie?" Ignoring my attempt to divert him, he keeps pressing, "What do you do?" "Nothing" was my answer. "Two years ago I was kicked out of Harvard's architectural school and I haven't found work yet." Pretending to care: "Oh! You are an architect. Well, my interview will make you world famous. What is your name?" I tell him my name. "Ah, you're French also. In the end you won't need any school. I will have people begging for your designs. Take a moment to collect your thoughts. Before I forget it, what is that strange thing you are wearing around your neck? Are you a Neo-Nazi? My father belonged to the Vichy in World War II." I carefully explain how I got it, and the fact that this was the first time I ever wore it. Continuing, I say: "After I get through here I plan to walk down

Rue Bonaparte past L'Ecole des Beaux Arts, giving the place an Italian salute, as it represents to me the "home office" of all design schools, then I will throw the medallion into the Seine and get on with my life." "Wow!" is his enthusiastic response, "Just like Hitler." His comparisons about my lifestyle are becoming both annoying and odious. As I start to get up to leave, he motions with his hand for me to sit down again. He reaches into his side bag just as a very long and loud passage from the accordion inside the cafe wafts its way out the open door, drowning out for a moment the chatter of those around us. Thinking he is about to pull out a pen and pad to begin "my interview," I relax a bit. But instead he now brandishes a small knife. Then he lunges forward toward my throat, cuts the pendant string, grabs the medallion before it falls to my lap, and runs laughing into the night. Later, alone by the Seine, I am filled with remorse for having betrayed the trust of Giuseppe Conti (the man who gave me the medallion) by allowing it to be snatched from me.

This episode did in the end have a positive note. I reaffirmed my childhood vow, made after first seeing the *TDTESS*, to become an architect so that I could design flying saucers. Had I thrown the medallion into the Seine, it would have symbolically been the end of my career. In 1990, twenty-five years later, and after an unspeakable struggle, I did become a registered architect. Two years later, in preparation for major oral surgery, I was subjected to a routine cat-scan of my head. As a result, a miniature metallic-like "implant" was discovered in my brain near the pineal gland. A local chapter of MUFON (Mutual UFO Network) declared it to be a "nanotechnological laboratory" capable of accelerating or retarding my brain activity like a benign tumor. I have come to believe that the implant is extraterrestrial in origin and is the main motivation of my ideas and theories. It was then that I knew I had been somehow forgiven and was back on track. But sometimes on warm summer nights, especially around June 2nd, I wonder just what did happen to that medallion that was passed on before its time.

I have analyzed Klaatu's ship as a form and have discovered that it conforms to the divine proportion, or Phi (0.382.../0.618...), in five separate ways, including not only linear but also mass and surface proportions. The traditional classical columnar orders (the Doric, the Ionic, the Corinthian, the Tuscan, the Roman Doric, and the Composite) only use Phi in three ways and for linear measurements only. To me, the form of the Thanaton, therefore, should be considered a new classical form.

What Robert Wise created by means of his movie was an actual piece of "built architecture"—a literaly new Jungian archetype or tulpa (the Hindu concept for a "degree of embodiment" from Brahma, or true reality, to Maya, our consensual world of physical illusion). *The Day the Earth Stood Still* is a piece of "tantric architecture" whose existence is verified not by walking up to it and giving it a kick, but by means of lucid dreaming in the lux theater of the mind.

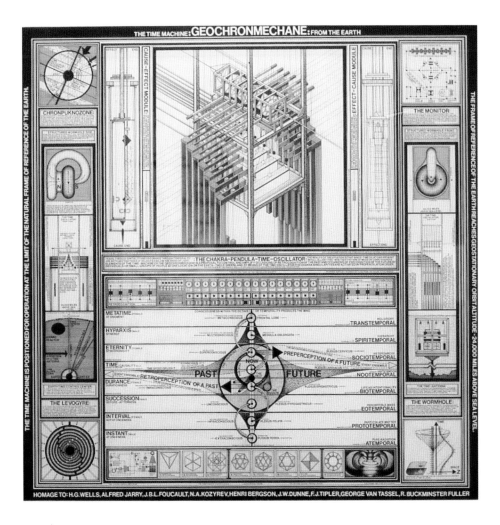

Paul Laffoley, Geochronmechane: The Time Machine from the Earth.
Ink and lettering on paper, 1990. 32 x 32 inches. Private collection, New York.

What It Is!—The Mothership Connection
Bill McBride

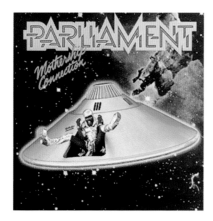

Parliament *Mothership Connection* album cover.

Well, all right!
Starchild, Citizens of the Universe, Recording Angels.

We have returned to claim the Pyramids.
Partying on the Mothership.
I am the Mothership Connection.
Gettin' down in 3-D
Light year groovin' . . .

Doin' it up on the Chocolate Milky Way
What's up CC? Have you forgot me?
Are you hip to Easter Island? The Bermuda Triangle?
Heh heh! Well, all right. Ain't nothing but a party!
Starchild here, Citizens of the Universe
I bring forth to you the Good Time
On the Mothership.
Are you hip?

"Mothership Connection (Starchild)" (George
Clinton, 1975) as recorded by Parliament.

38

Very near the end of my boyhood-favorite 50s flying saucer movie, the kid, David, wakes up again in his bedroom at 4:41 a.m.—as he had at the beginning of the film—to witness the same, cool UFO landing in his backyard, which we've just learned he didn't see . . . Ahah! Missing Time. It was all a prophetic dream—as was the entire film which displays: the zombification of his parents and most of the townspeople via back-of-the-neck cranial surgery; the freaky, wordless scenes of the Afro-coifed Femalien Head in a Jar who was recently dispatched from the Martian Mothership along with her "Big Ape" Zombie "mute-ant" henchmen; and Raoul Kraushaar's gloriously sumptuous chorus of disparate, pop-atonal voices striking an uncanny chord every time the Saucer's sand-pit landing site opens up with a corkscrew swoosh, sucking another earthling into the alien-run underground hive.¹ The boy goes back to sleep, his parents attribute the dream to "those trashy comic books he's been reading," and then, as a second saucer (though in reality, the first saucer) lands, the kid says a kid thing. He says: "Gee Whiz!" *Invaders from Mars* (William Cameron Menzies, 1953) manages to

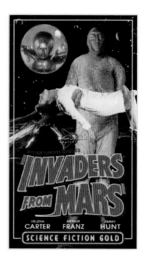

Invaders from Mars movie poster.

encapsulate nearly all of my ufological interests, while it helps channel impressions I get from some of the exceptional pieces in Conger and Blinderman's The UFO Show. This fifty-year old little green monster movie simultaneously:

> 1) dispels *and* endorses belief in UFOs and in so doing rather nicely captures the virtual ontological status currently allowed these alien ships at the end of the millennium by challenging epistemological categories—what it is/that it is not;
> 2) addresses a legitimate adolescent paranoia about adults and authority;
> 3) suggests and dismisses blame for the sightings on popular media saturation;
> 4) throws in classic American racial and sexual concerns of displacement and miscegenation;
> 5) insists on a privileged place in its scenario for alien sounds;
> 6) constructs a high-tech, yet deeply spiritual dystopia laced with an insect-coded, communist anxiety; and in the end
> 7) enunciates a child-like awe toward such visitations—precisely the enthusiastic approach I have adopted in order to reveal what "The Mothership Connection" is.

The wealth of UFO cultural material "out there" is as staggering as it is entertaining. Carl Jung, in his short, dense Flying Saucer book claims that UFO art both "heralds and eulogizes" the "gorgeous rubbish heap of our civilization."[2] If not for the irony or poignancy of the following statement, every UFO researcher might cry "God Bless cable television!" Aliens and UFOs seem to populate the blue tube 24/7. Allow me to acknowledge my debt in preparation for this essay to The Learning Channel's "Alien Invasion Week," The History Channel's week-long special "UFOs Then and Now;" the Discovery Channel's UFO programming, practically the entire output of the Sci Fi Channel—not to mention the Fox network who, in addition to "The X-Files," has given us "Futurama," re-runs of "3rd Rock From the Sun," and of course the infamous *Alien Autopsy*.

It must also be mentioned at the outset how tenaciously consistent reports are of the saucer image and of the abduction experience.[3] From the first modern sighting over the Cascade Mountains in Washington state by pilot Kenneth Arnold (24 June 1947) of nine weird ships flying in formation and moving "like a saucer would if you skipped it across the water," a convincingly impressive number of us have been witnessing both alien ships and their passengers. A relatively smaller, but nonetheless astounding, number—3.7 million Americans alone, according to the infamous 1991 Roper Poll—report these creatures have abducted them. A recent CNN poll found that 80 percent of Americans believe that the government is covering up knowledge of the existence of extraterrestrial life forms. How should we think about this monumental breach in all we hold dear when it comes to Western Rational Logic, our most cherished "reality tunnel"? Well, we traditionally tend to fall back on that logic for refutation or confirma-

tion. After about a decade of studying this phenomenon, Harvard's John Mack, now specializing in abduction trauma, poses the following intriguing question: *If alien visitations via UFOs and abductions are not happening, What is?* What follows is a fairly exhaustive list I've culled from a variety of sources of rational explanations intended to explain away extraterrestrial visitors:

Sleep Paralysis	Government Mind Control
Hypnagogic/Hypnopompic Imagery	Hoaxes
Plasma Vortex Phenomena	Bioelectrical and Neurophysiological
Lucid Dreams	Field Effects
Transient Memory Disorders	Electromagnetism
Near-death/Out of Body Experiences	Fantasy-prone Personalities
False Memory Syndrome	Earth Lights
Temporal Lobe Lability	The Collective Unconscious
Child Sex/Ritual Satanic Abuse	Earthquake Lights
Birth Trauma	Mass Hysteria
Ball Lightning	Shared Earth Theory

Appealing to the same basic rational logic, Mack, in a recent interview, cites his litany of evidence and observations in an attempt to confirm UFO reality: He finds an "authenticity and believability in the abductees themselves"—they are of above average intelligence, not given to flights of fancy in the rest of their lives, etc. There's an

> emotional intensity of the abductees' recall as indicative of trauma No one has ever come up with another trauma or set of traumas that could account for that emotional state—not rape, a war experience, childhood abuse, suppressed physical injury, parental attempted murder, attempted suffocation, etc.

He goes on to report that the basic structure of their stories "is exceedingly robust," replete with "narrative consistency. The ships may differ in size, the nature of the instrument changes, the shape of the doctor's head on the vessel changes. There are other characters they may see." Mack also claims that many of these abductions occurred before the recent media flurry of the 1990s. He finds an "absence of any kind of mental illness, much to the experiencer's chagrin." He notes the many "physical manifestations—changes in physical and chemical characteristics of the soil, nosebleeds, fresh cuts, or scoop marks upon returning to consciousness following a period of missing time." And of course there's the spectacular story of Linda Cortile's (an alias) abduction from her twelfth story apartment, witnessed by an international diplomat, his two security agents, and an elder woman crossing the Brooklyn Bridge.[4] So here you roughly have the two sides—skeptics and believers—names normally assigned the two ideological poles in theological debates, which of course is telling.

Jung's penultimate concluding sentence to his "UFOs in Modern Painting" chapter announces succinctly my synchronic cultural studies guiding principle in breaking down "what all" the Mothership Connection is: Credulity and lack of discrimination, which elsewhere would be vices, here serve the useful purpose of bringing together a collection of heterogeneous speculations on the Ufo problem.[5]

And as I have been gathering this motley range of human cultural material about the possibility of contact with, that is, the existence of, an other-worldly existence or race of beings, I have found that this UFO sighting/alien abduction phenomenon—what Jung calls this "worldwide rumor"—is part of a bigger problem. Now let's do some heterogeneous ufological speculation.

Faust: Bruste, wo?
(Faust: Where is Mother Nature's Breast?)
Goethe's Faust, Der Tragodie erster und zweiter Teil (line 456)

Take me up Tonight
"You Are My Starship" (Michael Henderson, 1976) as recorded by Norman Connors

Swing down, sweet chariot—Stop, and let me ride.
"Mothership Connection (Starchild)" (George Clinton, 1975) as recorded by Parliament

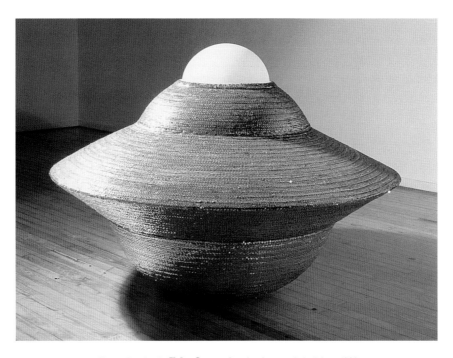

Sharon Engelstein, Flying Saucer. Sequins, foam, and plexiglass, 1998.
Collection The International UFO Museum and Research Center, Roswell, NM.

The "Mothership" traditionally is the term for the great pod vehicle that dispatches its smaller offspring vehicles or Earth Excursion Modules and immediately conjures up the Jungian mother breast *and* yonic shape to which most saucers conform.[6] Of the hundreds of Saucer images I have viewed (in this art show and everywhere else), Sharon Engelstein's Flying Saucer most blatantly and deliciously displays that Mother link, as it renders a sizeable (72" diameter by 54" high) and comely—zaftig, disembodied— breast: foam, sequins and all. This lovely female alien ship/shape as desirous object of a passive male is made manifest of course by all nursing infants, Romantics like Goethe, and, for my pomo Mothership purposes here, by its musical inculcation in Norman Connors' 1976 disco ballad "You Are My Starship," written and performed by jazz bassist and cosmic funkster Michael Henderson, who sings:

> You are my life. I have to go on. Have me any way you want to.
> Just take care and love me 'till my tension's gone.
> Cause you are my Starship. Come take me up tonight and don't be late.
> Yes you are my Starship.
> Come take me up tonight and don't be late and don't you come too soon.

There is something particular about the 1970s and UFOs, probably spawned by Erich Von Daniken's 1971 *Chariot of the Gods*, not to mention the fruition of 1960s cultural and ideational paradigm shifts. The UFO "fad" seems to start in the 50s with its dangerous rocket technology, flourish in the wigged-out 70s, and explode in the cyber 90s—skipping intermediate decades like Kenneth Arnold's saucers' movements as if skipping "across the water." Witnesses began talking to UFO researchers in the 70s. In the fall of 1975, *Newsweek*, CBS television and newspapers nationwide covered twenty people who trekked from a small town in Oregon in hopes of joining a UFO excursion—very Jefferson Starship/Heaven's Gate.[7] "You Are My Starship" was a popular "make-out" tune of the mid 70s, fondly remembered by commentators at *papasoul.com* as having a place in the "dark corner" of their minds, apartments and dorm rooms. The logical gesture of these lyrics somehow conflates being abducted by aliens with being intimately, sexually ravished by a loved one who is figured as the Starship herself, replete with the playfully admonishing, boudoir double entendre of "don't you come too soon." Woody Guthrie's recently resurrected lyrics (by Billy Bragg & Wilco) to "My Flying Saucer" (1950) made this cup and saucer/female lover equation twenty-five years before Connors and Henderson:

> My Flying Saucer where can you be?
> Since that sad night that you sailed away from me.
> My Flying Saucer I Pray this night
> You will sail back before the day gets bright.
> My Flying Saucer fly back for home
> You will get lost in the universe alone.

My Flying Saucer end all my fears.

Sail back tonight, love and kiss away my tears.

Jung interprets these semi-human alien figures as "feminine" because they are "unknown and indefinite," hence his famous anima who "personifies the collective unconscious, the 'realm of the Mothers.'"[8] Beyond this sexualized aspect of abduction and not-so-strange leftist bedfellows of white agit-folk balladeer and black funkster to which I will return, there's an additional apocalyptic/gospel origin in the UFO phenomenon made clear by Doctor/Professor Funkenstein himself, George Clinton.

In the song "Mothership Connection (Starchild)," Parliament repeats the following chorus/hook over and over again: "Swing down, sweet chariot—Stop, and let me ride." Whether it is 12th Century Christian mystic composer, painter and Abbess Hildegard Von Bingen or her fellow Christian mystics St. Theresa and St. John Chrysostomos or the millions throughout the years of faithful singers of the spiritual "Swing Low, Sweet Chariot" or the recently departed followers of Heaven's Gate, charioteer-wannabees the world over continue to believe the fiery vehicle is a comin' for to carry them home—just like their Biblical brothers Ezekiel and Elijah.[9] And in nearly every case that apocalyptic anticipation is an eroticized one. The visitations George Clinton and soul-brother mentor-predecessor Jimi Hendrix sing about are clearly religious, Christian in fact, and shot through and through with music. Clinton has the revival tent approach—"step up and be cured by the funk." And while P-Funk is much more Southern Black church, Hendrix speaks of a New Electric (blues) Church. Need I remind certain bad readers of the New Testament from the religious Christian right that not only is there nothing inimical in the connection between Christianity and a sort of leftist identification with the alien Other and Communist "group think," but rather it is at the core of everything Jesus taught. Followers of Jesus "were together, and had all things common; And sold their possessions and goods, and parted them to all men, as every man had need" (Acts 2.44-5, KJV). "And the multitude of them that believed were of one heart and of one soul: neither said any of them that ought of the things which he possessed was his own; but they had all things common" (Acts 4.32, KJV). Martians have long been considered messianic, dating at least back to Elijah's "abduction," if not to those depictions on 30,000 year-old cave paintings. And just what is that disc-like shape being pointed to in the background sky of the Fra Fillippo Lippi *Madonna and Saint John* painting hanging in the Uffizi?[10]

what it is/that it is not

Okay, there are all of these UFO images and reports of sightings. What are we to do with the lack of hard, material evidence? Skeptical scientists want to know. I have found nearly all UFO skeptics—those folks Robert Anton Wilson consistently calls Fundamentalist Materialists—to be cranky and cur-

mudgeonly and the ones with axes to grind, and this includes the author of *Contact*, Carl Sagan. It must be exceedingly difficult to catapult decades of "hard" scientific labor. "Believers" have done it. Believers are thought to be cranks, but Skeptics are the humorless, cranky ones, and here I am specifically targeting skeptical UFO Researcher and "scientist" Phillip Klass and feminist Elaine Showalter. In an interview that is part of *Nova On-Line*'s "Kidnapped By UFOs? Exploring the Alien Abduction Phenomenon," Klass attempts to refute alien existence with "humor": "Maybe they're mischievous Irish leprechauns; maybe they're the mischievous elves of Santa Claus; maybe they are agents of the devil—now I don't believe in any of these. But I have not spent 30 years investigating whether the leprechauns exist." Klass addresses the overwhelming similarity of reports and descriptions of aliens by nitpicking over occasional differences—again with his less than convincing humor:

> If that is similarity, then I suppose that somebody would say that Dolly Parton and I are quite similar. We both have one head, two eyes, one mouth, two ears, four fingers and a thumb on each hand. Similarity is like beauty, is in the eyes of the beholder. So if an extraterrestrial saw me standing alongside Dolly Parton, the extraterrestrial might say that I and Dolly Parton are similar. But I think the average human would say that we're quite different.[11]

Elaine Showalter in her book *Hystories: Hysterical Epidemics and Modern Media* sees alien abduction along with five other "psychogenic syndromes of the 1990s: chronic fatigue, Gulf War syndrome, multiple personality disorder, recovered memory of sexual abuse, and satanic ritual abuse" as a cultural symptom of anxiety and stress. Despite a culturally rich and well-researched book, in the end Jodi Dean argues that the UFO/alien abduction phenomenon is some sort of postmodern myth reflecting end-of-the-millennia anxiety about cyberspace and its digital/virtual undermining of truth—as if "truth" was ever given or available!

The "Believers" on the other hand are sober and respectful as they strive to describe and explain something inexplicable, weird, indescribable. John Mack and Thomas Kuhn, for example, argue for a paradigm shift in our worldview if we are ever going to "accept alien truth."[12] Copernicus, Darwin, Nietzsche, Freud, Leary and now John Mack present another blow to our Egoism. It should not be lost on us that the last two thinkers on this list are both renegade, visionary Harvard psychologists. Mack admits he cannot make a "claim about a phenomenon operating in the physical world—that is not my area," "I don't know what it is. Something's going on. It's interesting, it's scary . . . there's an authentic mystery here . . ." Mack thinks it's time "we grew up as a species, and rather than debate is it real or not, ask 'what do you mean by real? What does this really mean for us, for our cosmology, for psychiatrists clinically in terms of our categories, for us in terms of our relationships to the ecology and to the environmental crisis. What does this mean in terms of domains of reality?'"[13] Robert Anton Wilson in *The New Inquisition: Irrational Rationalism and the Citadel of Science* claims a "UFO is not

an extraterrestrial spaceship. It is an eitic [sic] event in space-time, which some humans file in their reality-tunnels as a "space ship" and other humans file as "mass hallucination."[14] Jack Sarfatti in California "says there's some kind of black time hole they (UFOs) come through from beyond space-time. They've mastered travel in and out of our space-time universe." Because of great contradictions and unexplainables, "some ufologists, especially Jacques Vallee and Karl Brunstein, are writing of the penetration into our reality by parallel worlds, even other universes. Vallee, for example, now states: 'I believe that the UFO phenomenon represents evidence for other dimensions beyond spacetime; the UFOs may not come from ordinary space, but from a multiverse which is all around us'"[15]

I find myself not wanting to discount the possible practical reality of UFO sightings and alien visitations. My position is not quite like Fox Mulder in that "I Want To Believe," it is more like I mistrust those who protest too much by adamantly refusing to believe. In the accompanying text above her fir tree horizon drawing, Amy Wilson cries out against "ethnocentric" skeptics who say "over and over again: 'WHAT I KNOW, I KNOW. WHAT YOU KNOW YOU ONLY BELIEVE" [see plate Research Begins page 75]. What I so admire in Ken Weaver's Abduction Series: Eternal Return Variation 3 (1996) is the referential *mise en abyme* that takes place, which as I've suggested in my opening discussion of the real saucer landing corroborating the dreamt landing of *Invaders From Mars,* neatly captures the "virtual" ontological status afforded UFOs by challenging epistemological categories. Weaver's painting at first seems to be a photorealist depiction of a video still of a monumental saucer hovering over a jeep, bus or pick-up truck at night due to its saturated, monochromatic blue screen color scheme. On closer inspection in person—this effect cannot be communicated by photographic slide, jpeg/gif imaging, or print reproduction—what one sees turns out to be a near three-dimensional canvas of luscious oil. The documentary evidential power of photography/film/video is at once elicited and withdrawn.

Ken Weaver, Abduction Series: Eternal Return Variation 3. Oil on canvas, 1996. Courtesy Sixth @ Prince.

45

Announcer: (Electric Pop Bass riff intro) Good Evening, ladies and gentlemen. Welcome to Radio Station EXP. Tonight, we are featuring an interview with a very peculiar looking gentleman who goes by the name of Mr. Paul Corusoe, on the dodgy subject of are there or are there not flying saucers or . . . ahem, UFOs. Please Mr. Corusoe, please could you give your regarded opinion on this nonsense about space-ships and even space people?

Mr. Corusoe: Thank you. As you all know, you just can't believe everything you see and hear, can you. Now, if you will excuse me, I must be on my way.

Announcer: (A wall of otherworldly electric guitar feedback chording). Bu . . . but, but . . . glub . . . I, I, don't believe it.

Mr. Corusoe: Pffffttt!! . . . Pop!! . . . Bang!! . . . Etc!!!?

"EXP" (Hendrix, 1967) as performed by The Jimi Hendrix Experience on *Axis: Bold as Love*

46

Left to right:
Pizza Hut logo
The Apple AirPort
Weber "One Touch"
Frisbees.

I'm trying to meditate on the ubiquity of this round yon saucer shape demonstrated again and again in Blinderman/Conger's The UFO Show, in most UFO sighting testimony, in nearly every single Hollywood saucer depiction, in the Pizza Hut logo, the shape of Apple's AirPort, the Weber charcoal grill, and let's not forget the preeminent Hippie toy— the Frisbee. In a moment I will suggest some implications that spring from the position "we are not alone." Jimi's Corusoe—whose name is meant to conjure Defoe's White European invader and ship-wrecked slave trader Robinson Crusoe (who was shattered when he discovered he was not alone), conqueror of the Black-skinned island resident Friday, thereby confusing the resident/alien equation—responds to the dismissive and condescending voice of British authority (Mitch Mitchell) by reminding the LP's faux radio audience and Jimi's own listeners to question official versions of reality. Jimi's alter-ego, Paul Corusoe, stands in here as a surrogate for all

earthlings who, for whatever reasons, believe in extra-terrestrial visitation, and who, like all writers and artists and film makers and pop songsmiths, present a version to their audience of this miraculous visitation: what the beings and their mode of transport look and sound like, what they do with and to us once they arrive, and why they are here. And like the defamiliarization of Swift's Hounynymic Horses and Orwell's farm animals, Jimi's alien's perspective is all about right here on Earth, today—a formalist veil for self-critique. Jimi's "Greetings Earthlings" says: "I just want to talk to you. I won't do you no harm." "I hear you got your people livin' in cages tall and cold." "I have been here before," etc. And when one race "discovers" another, along with colonialization, comes miscegenation.

Analee Newitz reads the abduction narrative as "a cautionary racial fable for our multicultural times . . . the alien abduction story teaches us that what we fear most is that white people are not the only people or beings who might try to take over and rule the world."[16] Along these lines of racial/sexual fear, an early 50s discussion of Invaders From Mars by the *Campaign Book Review* speaks of "the crisis of the gripping drama (which) is brought about in the *contamination* of U.S. citizens by the invading Martians. The destruction of the spaceship and its inhabitants, who are a terrible threat to all mankind, is finally accomplished by the U.S. Army."[17] Interestingly enough, a certain group of hip academics has begun to call academic interest in ufology "white trash studies," although it is a misnomer since the majority of abductees are well educated and middle class.[18] "White Trash" is a class-coding to which many politicized African-Americans object as being a refracted insult translatable into "White Nigger" (Norman Mailer's term for liberals), in that "white trash" Caucasians live and act very much like stereotypical lower income blacks. The most popular abductee couple is significantly the *interracial* Betty and Barney Hill, whose story is chronicled in *The Interrupted Journey: Two Lost Hours 'Aboard a Flying Saucer.* What is this perceived race and class connection/attraction to UFOs as demonstrated recently by Monday Night Football's hip, bratty color-commentator, polymath Dennis Miller, who claimed that Denver Broncos lineman Mark Schlereth, with his numerous arthroscopic surgeries "has been scoped more than a redneck abducted by aliens" (ABC-TV, 4 September 2000)? Parliament's *Mothership Connection* is a concept album of sorts, and what is that concept? It speaks of visitation by musical masters, funky invaders in your earhole. Hendrix writes often of this visitation, though it's usually a muse—an angel on a solitary visit. And he writes of it from both sides—alien and contactee. Jimi's alien persona appears on the Lp *are you experienced?* (1967) in the instrumental anthem "Third Stone From The Sun," where he observes Earth to be "strange-beautiful/jurassic-green/with your majestic silver seas/your mysterious mountains I wish to see close/may I land my dinky machine?" Afro-Alien Jimi is tired of monitoring Earth's radio waves filled with the Beach Boys ("never hear surf music again!") and finds Earthlings inferior to the planet's "superior cackling hen." The Hendrix alien experiencer persona can be found in such Christian-coded songs as "Angel" and "Little Wing." Angels . . . Aliens . . . What's the difference? It's telling to note here that those who believe they have been abducted by aliens prefer to call themselves "experiencers." Clinton also writes

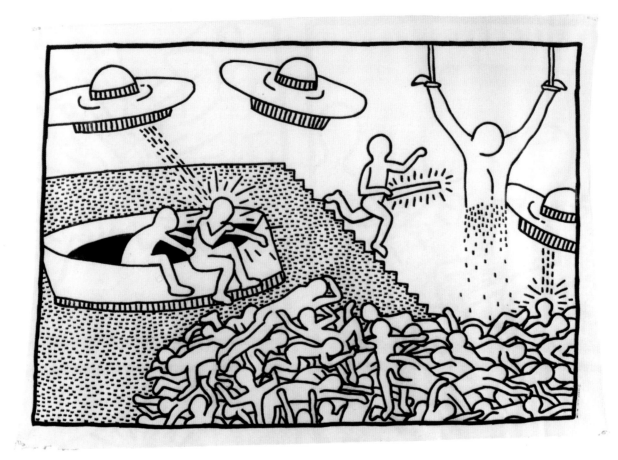

Keith Haring, The Blueprint Drawings, Silkscreen on paper, 1990. Courtesy the Keith Haring Foundation.

of the UFO experience from both sides. In "Unfunky UFO" from *The Mothership Connection*, the Friday-like experiencer Clinton fears the imperialist Crusoe-like alien has come to Earth to rip off the funk: "Oh, but like a streak of lightning it came/Filling my brain with pain/Without saying a word, this voice I heard/'Give up the funk, you punk!'" But for the most part Clinton the Starchild is empathetic with the freaky, funky alien boogie man. The funk is all about hybridity, just as is the alien agenda to mate grays and humans.[19] Aliens are a race referred to by skin color. Witness the liberal mantra: "Be they white, black, red, yellow, brown, or green . . . or gray." And the liberal insight at the heart of nearly every alien monster movie is that *we* are the aliens, *we* are the monsters—a Hollywood insight that need not preclude the existence of flying saucers.

making love was strange in my bed
"Roomful of Mirrors" (Jimi Hendrix , begun 1968, released 1971)

By all reports Jimi Hendrix devoured the works of the 1952 Hugo Award winning sci-fi-ist Phillip Jose Farmer, who is noted for being, among other things, an explorer of human/alien sexuality. Keith Haring's UFO print, The Blueprint Drawings, based on a drawing from 1981, directly addresses the sexual abuse and molestation often associated with abduction. It depicts in the top background two classically shaped saucers hovering over an edifice and pile of conquered, inert bodies with a third saucer in the lower right background. One of the top ships is sending down its tractor beam, zapping one of two Haring figures as they climb out of some sort of escape hatch which is attached to the generalized building that to the right contains a set of stairs down which runs another figure burdened with holding in his right hand his terribly oversized vibrating power rod (propaedeutic to semen extraction by the aliens?) while pointing with his left hand at a fellow figure who is bound and hung from somewhere above the picture's frame and whose lower torso is nearly entirely disintegrated. The lower right saucer is also head-zapping one of the bodies in the pile. This work comes from that particular New York-gay-New Wave early 80s time whose circle included fellow alien Kenny Scharf—who with his piece from The UFO Show entitled Chiki [see plate on page 103] even figures a flying saucer in his customized vacuum cleaner—and self-proclaimed alien, rock star Klaus Nomi. Haring's sex-apocalyptic vision here can proleptically be read as an AIDS nightmare. The alien abduction nightmare narrative consistently contains anal probing as well as sperm and egg extractions for the purpose of developing a human/alien hybrid. Jimi's alien arrives looking for one of our barnyard animals—perhaps with which to breed. And the persistent way of figuring the extraterrestrial Other—when not as African—is as insect.

The Angry Red Planet
movie poster.

One hundred years ago H. G. Wells depicted one of the first extraterrestrial dystopias to feature the insect-as-alien with his novel's great colony of humanoid ants inhabiting the lunar surface and underground in *The First Men in the Moon* (1901). Leon Stover, editor of the new annotated edition of the "scientific romance," argues Wells' anxiety toward the international scientific management movement, specifically the Saint-Simonian school of socialism, is made manifest in this loony lunar nightmare. What may be even more frightening of course is the attendant proposition of a genuine (unlike his England's only titular Queen Mother) and genetically entrenched matriarchy—crucial to the Mothership connection. Insects, Communism, Matriarchy—Oh My! *Invaders from Mars* presents a similar scenario and fear as the Queen head-in-the-jar Martian Leader "Intelligence" rules over her zombie drones. Each actor curiously mispronounces the name "mutant" that they assign the drones, insisting on calling them "mute-ants." The anxiety operating in these alien-insect bad dreams is the (particularly American) free market-capital fear that democracy's core belief in individualism is under attack by communism's ant colony/bee hive mentality. In his analysis of a patient's alien spider dream, my authority on UFO and alien anxiety writes of the commonly held "hypothesis that UFOs are a species of insect coming from another planet and possessing a shell or carapace that shines like metal." Jung remarks that he was "struck" how "the peculiar behaviour of the UFOs was reminiscent of certain insects." He continues in a footnote: "Sievers, *Flying Saucers uber Sudafrika*, mentions Gerald Heard's hypothesis that they are a species of bees from Mars (*Is Another World Watching? The Riddle of the Flying Saucers*). Harold T. Wilkins, in *Flying Saucers on the Attack*, mentions a report of a 'rain of threads,' supposed to come from unknown spiders." Jung provides the key to this nervous insect projection: "Spiders, like all animals that are not warm-blooded or have no cerebrospinal nervous system, function in dreams as symbols of a profoundly alien psychic world."[20] *The Angry Red Planet* (1959) connects as well with this Mothership fear by presenting us with a curiously ugly Martian bat-lobster-spider hybrid. The film also assigns comeuppance to a wimpy, peace-loving and alien-loving professor (Les Tremayne) donned in beatnik-commie goatee.

Artist and experiencer John Velez, when pushed by *Nova On-Line* to come out with his theory regarding these abductions, finally goes on record with the following alien/human hybrid hypothesis:

> All right, this is pure speculation on my part. Because I don't think anybody knows for sure. With the exception of the aliens and maybe Uncle Sam—and they're not talking. What I think is going on is, I believe these creatures have always been here. I believe their role is basically a caretaker role. I believe that their race is incapable of reproducing itself. And that these beings have lived in a symbiotic relationship with mankind throughout the ages. They need us in order to reproduce themselves. I believe that that's what the hybrids are. I believe the hybrids are just simply more of them. I honestly can't say, with any authority, that they're from another world—

although, they may be originally—or what their ultimate purposes are here. I mean all of this could very well be a preamble to invasion, for all I know. [21]

I argued earlier that the cup and saucer shape conjures pleasurable yonic and female breast images, and broke down the logic of sexual ravishment in the lyrics to "You Are My Starship" in order to begin to suggest the sexualized aspect of abduction. While Jung is careful to admonish that "sex is not the sole instigator of these [UFO] metaphors," he does allow "there is a close association between sexual instinct and the striving for wholeness. With the exception of religious longings, nothing challenges modern man more consciously and personally than sex." He also writes about how the UFO believers' unconsciousness "strives to fill the illimitable emptiness of space" with these "numinous images" intended to sate the "hunger of the soul."[22] The anticipation of the apocalypse by History's charioteer-wannabees is necessarily an eroticized one—and rarely without musical accompaniment.

what it is!

The Mothership Connection is also a link between Mother African culture and its particularly American hybrid music. My essay's title—replete with Black English Vernacular, the Ebonical "What It Is!"—comes from Parliament's 1975 Sci-Fi Hi-Fi LP recorded during the ascendancy of disco, another triumph for George Clinton and black "rock and rollers" in general. This triumph began with colonial slave songs, but specifically for our purposes, began when yet one more African musical synthesis with Protestant churches coincided brilliantly alongside: Atom Bomb testing in New Mexico, UFO sightings at Roswell, routine emission from Earth of radio and television signals, and the "birth" of that otherworldly, mutant gospel music known as Doo-Wop. Seemingly secular, with its theremin–like falsettos, creepy vocal bass lines, and ultra-electric production, this otherworldly sounding music of the mid-to-late 50s caused a widespread panic when it first appeared on our shared airwaves. Owing to this bizarre sound and theory of outer-space origin, I was predisposed to mishear the top-40 AM radio doo-wop song "Mr. Bassman" by Johnny Cymbal as "Mr. SPACEman,"

(Bop-bop-bop singing by bass voice)

Mr. Bass Man, you're on all the songs
B-did-did-a-boom-boom, B-dit-dit-a-boom-boom-bom
Hey Mr. Bass Man, you're the hidden King of Rock 'n' Roll, d-d-b-bop-a-bop
(Bass voice: No no, b-b-BOP-p-p-bop bop bop . . .)

It don't mean a thing when the lead is singin'
Or when he goes "Hi-yi-yi-yi-yi-yah"

Hey Mr. Bass Man, I'm askin' just one thing:
Will you teach me? Yeah, the way you sing?
'Cause Mr. Bass Man, I wanna be a bass man too, d-d-b-bop-a-bop
(Bass voice: Try this, b-b-BOP-p-p-bop bop bop . . .)

I was not far off "base" in thinking the Spaceman was the "hidden King of Rock and Roll," particularly given another of Johnny Cymbal's hits, "Robinson Crusoe on Mars." Doo-Wop was the perfect genre in 1959 for this Boss-Tones ditty entitled "Mope-Itty Mope" about a "leftist" outer space girlfriend (covered by the Dovells in 1962):

(Raspy, buzz Bass voice)	Mope-Itty Mope Mo Me Mo Mo Mo
(Chorus repeats)	Mope-Itty Mope Mo Me Mo Mo Mo
(Bass)	Ditta ee Idee I Ya Ya Dee Ah Ya Ya
(Chorus)	Idee I Ya Ya Dee Ah Ya Ya
(Bass)	Deeta Weed Ah Wee Wee Dah Wee Wee Wee
(Chorus)	Weed Ah Wee Wee Dah Wee Wee Wee
(Bass)	Deeta Mope-Itty Mope Mo Me Mo Mo Mo
(Chorus)	Mope-Itty Mope Mo Me Mo Mo Mo
	Woo—oo Woo—oo
(Bass & Chorus)	Mope-Itty Mope Mo Me Mo Mo Mo
	Mope-Itty Mope Mo Me Mo Mo Mo
(Bass)	Well I just got back from Outer Space
	Well I met a baby that had no face
	Well three left arms and four left feet
	Well when she walked she skipped a beat.
	Took her to a record hop.
	Showed my baby how to bop, goin'
(Bass & Chorus)	Mope-Itty Mope Mo Me Mo Mo Mo
(Tenor)	Everyone was at this place.
	To dig this chick from outer space.
	Whoah. People came from miles around
	To see what she was putting down.
	She took to left, did the Slop.
	The Up Girl there was doin' the Bop. She was
(Bass, Tenor & Chorus)	Mope-Itty Mope Mo Me Mo Mo Mo
	Mope-Itty Mope Mo Me Mo Mo Mo

```
(Bass)                    Now here's a dance from outer space.
                          Well catchin' on all over the place.
                          His brave little girl and takes the moon
                          And harmonizes with every tune.
                          All the people on Planet Earth
                          Try the new dance and you'll be worth doin'
                          Mope-Itty Mope Mo Me Mo Mo Mo
```

"Mope-Itty Mope" (Boss-Tones/W. Chatman, 1960) as performed by the Boss-Tones

While critics (like me) pride themselves with detailed and logical rock and roll origins, there remains something undeniably *sui-generis*, something untraceably "new" about rock which continues to this day—it is the music of youth and it is its youth-cult status and otherworldly element which links it to ufology. It requires a "youthful" mind to seriously entertain UFO probability. Now I ask you, what's more engaging and engrossing—speculating on the existence of exotic UFOs or debunking them as sleep paralysis, false memory, swamp gas? These "debunkers" are the same pundits who feared and condemned rock and roll. These (usually) politically conservative doubters have consistently dubbed rock and roll one or more of the following:

1) music from outer space,
2) music named for and complicit with all types of sexual activity,
3) music of the devil delivered by the black man,
4) music pipelined in from the communists.

This sexualized alien black commie core explains much of the UFO phenomena and many of the reactions to it: the feminine shape of the saucer, the psycho-gynecological trauma (thousands of Virgin Martian Marys recount their annunciations and assumptions under regressive hypnosis), the apocalyptic gospel musical aspiration for heaven or lust for the eternal which allows a consolation for heartbreaking intergalactic and universal solitude, the fear toward a miscegenetic and techno-dystopia. How bizarre it seemed when I was younger that the extremely creepy Martian Leader in *Invaders From Mars*—that head in the jar the credits list as "The Martian 'Intelligence'" (played by Luce Potter, "Midget" from *The Incredible Shrinking Man*, 1957) and who in the film is referred to as "he"—would look so uncannily, so unmistakably like the disembodied head of a *black* female. But then again who was the most underrepresented American figure by 1953 (or 1963 or 1973) in Hollywood other than the African-American female? And when the white male creative intelligence of the time attempts to conjure up an odd, intimidating, unapproachable (but also somehow cryptically desireable a la Joseph Conrad's "The Intended") Other, who better than this Afro-Femalien? Not only are you My Starship, my musical Mothership Connection, you turn out to be my most repressed because *verboten* object of

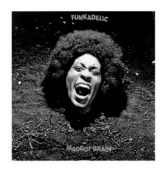

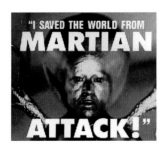

Top: Funkadelic album cover.
Bottom: Invaders From Mars

desire according to the hypocritical but absolutely entrenched rules of American sexual politics.

Jodi Dean argues how ironic that ufology's very stigma makes it "seductive and transgressive. Those of us attracted to left-wing causes, to critical positions against political, governmental, and corporate authorities, or maybe just to underdogs in general may feel at home in ufology."[23] Notice also how "domesticated" aliens have become, as in the TV show "Third Rock From the Sun"—one forgets they are aliens and tends to think of them as merely spaced-out counterculture 70s refugees like Robin Williams' spacey Mork of "Mork and Mindy," Ray Walston's affected 50s beatnik-Professor type of "My Favorite Martian," or Jerry Lewis' childish pixie in *Visit from a Small Planet*. Taking a musical, cerebral, or intergalactic trip aboard a sailing ship—whether it's with Dylan's "Mr. Tambourine Man," Roger McGuinn's "Mr. Spaceman," Jerry "Captain Trips" Garcia, the crew of Paul Kantner's (pre-Heaven's Gate) Jefferson Starship, or a group of gray, technologically superior ova and sperm curious aliens—each excursion nicely conforms to the alienated trip of LSD, or magic mushrooms, or of Buddhistic meditation. One becomes *alienated* from one's ego. In his book *Abduction: Human Encounters with Aliens*, John Mack states the contactees' similar experience this way: "They shed their identification with a narrow social role and gain a sense of oneness with all creation, a kind of universal connectedness."[24] Of course this interconnectedness can get mighty heady. The consistent humbling effect of these trips results from the sublime, awe-full revelation that not only is one not alone nor a lone, single monad in the universe, but neither is one master of that universe. One might term the result of such an experience The God Effect, described by Jung as "religious experience," whereby *"man comes face to face with a psychically overwhelming Other."*[25]

we're not alone

text from poster in Special Agent Fox Mulder's office

**esse est percipi
(To be is to be perceived)**

Bishop Berkeley

loneliness is such a drag

"Burning of the Midnight Lamp" (Hendrix, 1968)

I think it's significant that the soundtrack to *The X-Files* film (1998) opens with Filter's version of Harry Nilsson's "One"—"One is the loneliest number that you'll ever do . . . One is the saddest experience you'll ever know." Now, while I would not want to claim outright that all folk of the ufological persuasion are cultish loners, i.e., lonely people who find each other in common experience and cause, I am nonetheless compelled to point out that in the entire unexamined-life-is-not-worth living—paranoid/oblivious—ignorance-is-bliss behavior dynamic, those who are self-reflexive, intellectual, and anti-authoritarian necessarily are *minor* in some way. Jodi Dean mentions in passing that "abduction provides cultural expression of the confused passivity accompanying the collapse of the real."[26] There's an undeniably masochistic ("take me up tonight"), victimological pole in anyone whose position allows for the Other—alien life, whether terrestrial or extraterrestrial—what John Mack would call an allowance for "the unseen realm. What we seem to have no place for—or we have lost the place for—are phenomena that can begin in the unseen realm, and cross over and manifest and show up in our literal physical world."[27] The ability to identify with an Other necessarily betrays a liberal bone or two in one's body—and here lies a key to the black and leftist attraction to the UFO phenomenon. It's mostly the alternative kids (black and white) who show up in my classrooms wearing "X-Files" and alien grey T-Shirts. It's mostly spacey jazz-fusion, funk, and alternative rock groups who write and sing about UFOs and aliens. Then too, there may be a maturity issue here that turns on the strength and ability to accept the proposition that *we are on our own*—a chilling/enthralling proposition Bob Weir and John Barlow confront in the Grateful Dead's apocalyptic/hopeful warning called "Throwing Stones":

> So the kids they dance they shake their bones. *'Cause it's all too clear we're on our own.* Singing ashes, ashes all fall down. Ashes, ashes all fall down. Picture a bright blue ball just spinning, spinning free. It's dizzying, the possibilities.[28]

Riding alone on my bike out into the corn and bean-fields of rural Illinois late one recent June night to better glimpse the big gibbous moon "rise" over the horizon, I was reminded—apart from a brief *Children of the Corn*-like shudder—of having similar feelings of breathtaking solitude beneath the big

55

sky in Arizona and Mexico. It is certainly no surprise and no secret that the wealth of sightings occur in the desert. One only need try to account for the recent mass sightings (millions of eyewitnesses and multiple amateur videographers) on New Year's Day 1994 in Mexico and the thousands of corroborative witnesses of the spectacular UFO display in the Phoenix sky reported by all the local media in March 1997, and one is led to ask: Why this desert locale? Limitless visibility certainly is keen and key—but more is going on here. At least since the days of Abraham and his cult of Yahweh, the desert has always required of us a certain sublime, spiritual response.

In their very funny and insightful 1974 LP *Everything you know is wrong*, the Firesign Theatre manage

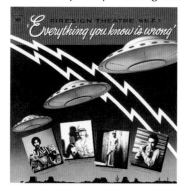

Firesign Theatre *Everything you know is wrong* album cover.

to synthesize UFO sighting/alien abduction with Carlos Castaneda (his hallucinogens, ancient native shaman wisdom, and bird comrade), communistic brainwashing ("everyone must learn to play the piano!"), New Age desert religion, and "Gas Music From Jupiter"—setting it all in the scorching desert of "Hellmouth, California." Counter-cultural interest in UFOs moves from the (mostly) grade "B" outer space movies and pop songs ("Purple People Eater," "Mope-Itty-Mope") of the 50s to the Hippie and nascent New Age interest in the late 60s/early 70s—in addition to the Firesign Theatre I am thinking specifically of the pot smoking lesson and discussion of a very real alien invasion under the nighttime desert sky between the believing Dixie attorney George (Jack Nicholson) who tries to convince the skeptical spaced cowboy Billy (Dennis Hopper) in *Easy Rider* (1969) and Fleetwood Mac's "underground FM hit" "Hypnotised" (by Robert Welch from *Mystery to Me*, 1973)—all three mention separate realities, saucer evidence, and Mexico.[29] Skeptics would be satisfied with the following glib analysis—a drug-induced desert *mirage*.

The Roswell crash site is not only significant because it occurred in the desert, but because it persists as a terrifically "loaded" locale due to the atomic weapons testing conducted nearby, not to mention that in 1947 Roswell Army Air Field housed the 509th Air Group—solely responsible for delivering the atomic bomb. Those only passingly familiar with UFOs certainly have at least inklings about the connection between that privileged military site as the first crash site and the compelling alien message that we must wean ourselves away from developing technological means of mass destruction before it is too late. This alien alarm is a direct response to scientific, species arrogance, to a kind of earth-bound hubristic, solipsistic worship of genius, and is, needless to say, a particularly "Hippie" insight. Here is also more of the God Effect in that Tower of Babel/Garden of Eden sense: a superior force chastises reckless overachievers.[30] While there's something potentially paranoiac (in an Orwellian-Pynchonian/X

Files/JFK conspiracy way) about the notion that someone is watching us and taking note, there's also something existentially affirming (in a Berkeleyian way) and frankly complimentary and comforting (in an ego-stroking, "hey Mom and Dad look at me!" childlike way). In his spectacular and very early UFO contact account *The Secret of the Saucers* (first abduction reported 4 August 1946), Orfeo M. Angelucci transcribes the following pronouncement from his alien kidnappers:

> The people of your planet have been under observation for centuries . . . Every point
> of progress in your society is registered with us. We know you as you do not know
> yourselves. Every man, woman, and child is recorded in vital statistics by means of
> our recording crystal disks.[31]

I think of Yahweh's big book of life and deeds, referenced variously in the Pentateuch, Psalms, and in that tripped-out, intergalactic prophecy by St. John the Divine, the mystic Jewish-Christian Book of Revelation.[32] Yes there is a comfort and consolation in the notion that someone knows us better than ourselves . . . and cares! Jung connects UFOs with "God-images." Both are "often associated with fire and light," both are "round, complete, perfect."[33] The day after the opening of The UFO Show, I participated in the panel discussion "Ufology and Art" alongside Claire Jervert, Amy Wilson, Ken Weaver and Barry Blinderman, and was particularly struck by what Claire Jervert revealed regarding her working process. Like the alleged activity of aliens, she tirelessly monitors and records TV shows looking for images and information she can use, such as her "Video Still." In true conspiracy-seeking style, Ms. Jervert also uncovers evidence of subliminal messages in both advertisements and feature programming.

Pink Floyd's *A Saucerful of Secrets* album cover, 1968.

a saucerful of secrets

Then at last the mighty ship
Descending on a point of flame
Made contact with the human race
And melted hearts

"Let There Be More Light" (Roger Waters, 1968) as
performed by Pink Floyd on *A Saucerful of Secrets*

The nature of Angelucci's aliens' "crystal disks," which contain all of this intimate, personal data about us, seem to preternaturally anticipate our fairly recent CD-ROM technology. But is it "ours?" According to Retired Colonel Corso, the recovered UFO at Roswell has been a sort of Saucerful of Secrets whose "artifacts" the United States military has "harvested," and via

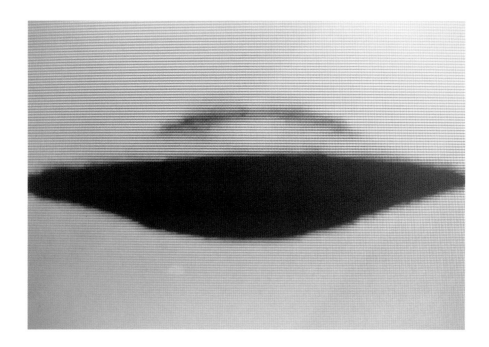

58

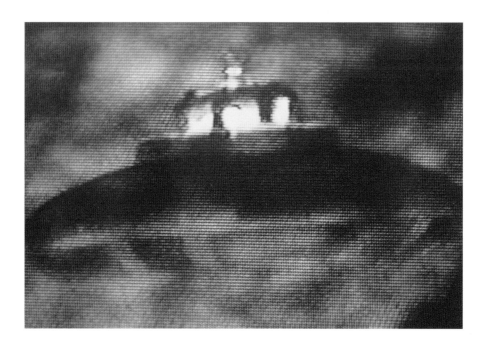

Above: Claire Jervert, 1/1998oz-1. Cibachrome print on honeycomb aluminum panel, 1998. Courtesy Steffany Martz Gallery.
Below: Claire Jervert, 10/1998oz-2. Cibachrome print on honeycomb aluminum panel, 1998. Courtesy Steffany Martz Gallery.

"negative engineering," has exploited the alien technology in ways that has led to the development of: Integrated circuits, Fiber optics, Lasers, and the Stealth technology.[34] But the most compelling aspect of Angelucci's account is his continual return to the alien music. Aboard the Mothership he hears:

> a kind of humming, a rhythmical sound like a vibration, which put him in a semi-dream state. The room grew dark, and music came from the walls Through the window he saw a UFO about one thousand feet long and ninety feet thick, consisting of a transparent crystalline substance. Music poured from it, bringing visions of harmoniously revolving planets and galaxies.

In his analysis of Angelucci's account, Jung harps on, but doesn't analyze, the "almost incessant" and "obligatory etheric music."[35] In the pop music realm, as I've already suggested, we move from 50s doo-wop and novelty records (have you heard Buchanan & Goodman's 1956 "Flying Saucer"—a Wellesian "interrupted broadcast" of 50s hooks depicting doo-wop singers as aliens) to Pink Floyd and Jimi Hendrix in the 60s; Bowie, Boston's album art, UFO, Jefferson Starship in the 70s, Newwavers like Gary Numan, B-52s, and Klaus Nomi in the 80s, and then just a pop musical explosion in the 90s, headlined by Roswell Records' the Foo Fighters (named after lights that accompanied the Allied bombers over Germany (Foo-feu) which were thought to be UFOs)[36] and Special Agent Frank Black, formerly of the late 80s alternative-pop band the Pixies ("Motorway to Roswell"). Claiming the youthful mindset necessary for UFO faith in his song "Space Is Gonna Do Me Good" ("I'm done with adult matters"), Frank sings specifically of the Afro Mothership Musical Connection I've been attempting to forge when at a "UFO convention" he gets "patterns from a trekker and it sounds like soul records to me"—early reggae-pop in fact—as he goes onto to clarify: "Patterns from a trekker, sounds like Desmond Decker to me."[37]

While I've been figuring the Mothership music as receiving its alien quality from Africa and its space-age electronics from Rock, the *de rigeur* Hollywood and TV sound of aliens in the 50s and 60s is produced almost exclusively by the theremin. Is there anything more alien sounding on this planet than the warbles produced by this truly bizarre, spacey instrument? For example, whenever "Uncle Martin" performs an alien act on "My Favorite Martian," it is conferred authenticity via theremin accompaniment. Invented by Professor Leon Theremin in 1920, it works by means of low power, high frequency electromagnetic fields around antennae, employing a beat frequency oscillator. Beyond its "artificial," radio-electronic sound source, the theremin performer "plays without the benefit of any tactile reference whatever . . . the thereminist feels no shape or force as he moves from one pitch to another." There is neither attack nor decay, the creepy sound literally creeps up on you. As premiere thereminist Clara Rockman once put it: "today's 'space conscious' listeners are interested in electronic music, and what is more natural to electronic music than a space-controlled instrument?"[38] The sound produced by the theremin is a bit like the musical buzzing of a fly and therefore connects also with the alien-

insect phenomenon. In Mark Snow's "X-Files Theme" we cannot mistake the theremin-like synthesized whistling-in-the-dark main melody (not to mention the cheesy "Dr. Who" theme). What is it about that sound? The aliens in Spielberg's *Close Encounters of the Third Kind* are all about communicating with humans by means of a catchy five note melodious hook. *Invaders from Mars* privileges that eerie alien SOUND. In his mixed media UFO Show piece "Forget SETI," Andrew Detskas throws down the following gauntlet: "What if an alien life form evolves on a planet with its sensory acuity centered in its auditory system—a world absorbed by the intricate movements of sound waves?" He asks us to ponder a version of John Mack's "unseen realm" by challenging us to wrap our minds around an alien concept. These then are the sound connections I have been unpacking throughout this essay, and you know, the rhythm may be as clunky as John Williams' square alien anthem from *Close Encounters*, or as future-funky as the music of P-Funk or your Mother's heartbeat or as numinous as a soul record, that is, a recording of your own soul.

a concluding experiment

After having written the essay above, and in the spirit of the scientific method, I decided to test my Mothership Connection hypothesis on a recent Hollywood blockbuster UFO movie I had yet to see— a kind of blind taste test—so I screened the much ballyhooed and subsequently booed *Independence Day* (1997). I had been right to resist the production company's initial hype: To my dismay, sitting through the film was a dreadful bore, which led me to wonder—um, Director Roland Emmerich, how do you make an unintentionally laughable and relentlessly un-entertaining movie about an alien invasion that brings us to the brink (4 or 5 times) of the end of the world? The same way you botch a movie about the big radioactive lizard *Godzilla* I guess—two BIG films that proved size does NOT necessarily matter. But to my immense heterogeneously speculative and scientific delight, *Independence Day* wants it both ways and features prominently a number of key ideological ingredients of my Mothership Connection. The "profoundly alien psychic world" of the insect and the hive/communist group-think fear of the 50s surprisingly remains. After a brief alien mind-meld, President Whitmore (Bill Pullman) reports: "I saw . . . his thoughts. I saw what they're planning to do. They're like *locusts*." It is also made clear throughout the film that those "alien groupies" as they are called in the script are those left-wing lunkheads Jodi Dean pegs in her book. Looking like a touring troupe of the American Tribal Love-Rock Musical *Hair*, they have gathered on an L.A. rooftop with welcoming signs and innocent, sappy alien desire only to get mercilessly zapped by Emmerich's boogiemen. Here is liberal critique at its flimsiest. And in case we've missed any of this message—like President George Bush at the "end" of the Gulf War announcing that America has finally "kicked the Viet Nam Syndrome"— Emmerich attempts to kick the late 70s/early 80s post-hippie love affair with aliens by kicking the Steven Spielberg Syndrome.

Tough-talking, no-nonsense African-American Captain Steve Hiller (Will Smith), who earlier in the film announces to his group leader and fellow fighter pilots to great laughter and applause that he's "a little anxious to get up there and whup E.T.'s ass," captures one of these alien invaders by smacking him unconscious upside the head accompanied by his next "memorable lines": "Welcome to Earth! That's what I call a close encounter!" It should not seem strange that this character (and this actor who notoriously refused to kiss another male actor in *Six Degrees of Separation* and therefore became a darling of the Right) is given these politically revisionist attitudes and lines. As espoused by the terrifically successful current up-start leader of the Oakland Chapter of the N.A.A.C.P, this is the new wave of African-American politics that seeks a Buppie-inspired distance from old school leaders like Jesse Jackson (who is impersonated in the film by the Caucasian pilot/class clown). But, as I've suggested, this film wants it both ways—it conducts this reactionary sniggling at perceived hippie-liberal weakness while at the same time revels in Roswell/Area 51 truth by corroborating conspiratorial fears of a U.S. Government cover-up of the 50 year reality of UFOs. Of course the true weakness is on the filmmaker's part—a weakness nailed by Nick Cave in his song "Red Right Hand":

> You ain't got no self-respect, you feel like an insect
> Well don't you worry buddy, cause here he comes . . .
> You'll see him in your nightmares
> You'll see him in your dreams
> He'll appear out of nowhere but he ain't what he seems
> You'll see him in your head, on the TV screen
> And hey buddy, I'm warning you to turn it off
> He's a ghost, he's a god, he's a man, he's a guru
> You're one microscopic cog in his catastrophic plan
> Designed and directed by his red right hand
> "Red Right Hand" (Nick Cave, 1994) as performed on *Let Love In*

Emmerich's fear springs from a colossal human inferiority complex when it comes to technologically superior aliens who the film's President finally "nukes" because he's *man enough*—kicking the Kennedy/Johnson/Nixon Viet Nam Syndrome—declaring "independence" from said superiors at the end. Now for most of this whacky business I had been prepared by Tim Burton's self-loathing, disappointingly cynical *Mars Attacks!* (1996) with its send-up of a Clinton-like, liberal, trusting President played by Jack Nicholson. What I wasn't prepared for, though I should have been since my theorem had predicted it, was the encrypting of the alien as not-so-vaguely *African-American*. As Captain Steve Hiller carries the body of the unconscious alien back to the secret Roswell base, he talks to him as a brother—and I mean as both a sibling and a "bro":

61

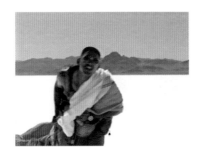

Video stills from **Independence Day**, 1996.

Y'know, this was supposed to be my weekend off, but noooo. You got me out here drag-gin' your heavy ass through the burnin' desert with your dreadlocks stickin' out the back of my parachute. You gotta come down here with an attitude, actin' all big and bad . . . and what the hell is that smell? I could've been at a barbecue! But I ain't mad.

Dreadlocks eh? "Patterns from a trekker, sounds like Desmond Decker to me." Leonard Maltin says *Independence Day* manages to "make some silly 50s sci-fi movies look brilliant by comparison." Emmerich's block-*bluster* returns us to figuring the alien the old fashioned way, but not nearly as mag-ically and imaginatively as *Invaders From Mars*—no. Nor any gentle, inquisitive Spielbergian grays who benignly only wish to encounter us closely and then return home with some pieces of candy-coated peanut butter and chocolate. Gee Whiz!

Notes

1 DVD Savant is hip to the film's SOUND. He writes about "an eerie, stomach-twisting vocal effect that seems to be an inversion of a stock 'heavenly chorus.' This collection of slippery tones is incredibly creepy, and will grab the attention of any child. It's far more disturbing than the Theremin, if only because of that instrument's overuse. The chorus seems to be part of the musical score, until Sgt. Rinaldi is taken in the Sand Pit. David blurts out, 'That noise!' as if hearing it for the first time. Do the Martians sing as they operate their sand-trap, or is David hearing the soundtrack of his own dream? Later, both David and Pat hear the 'music' just before they are captured. And the entire cast reacts similarly to a choral burst as the saucer prepares to lift off. The logic of David's dream fully enlists the soundtrack in its surrealism." DVD Savant's on-line *Invaders from Mars* essay, Part 2:http://www.dvdresource.com/savant/s97 InvadersB.shtml.

2 *Ein moderner Mythus: Von Dingen, die am Himmel geshen werden* (1958) translated by R.F.C. Hull as *Flying Saucers: A Modern Myth of Things Seen in the Skies*, MJF Books, p. 77.

3 As the "Government's UFO Expert" Nick Pope in *The Unvited: An Expose of the Alien Abduction Phenomenon* (Overlook, 1997) puts it: "The sheer volume of reports, the commonality in independent accounts coupled with the physical and emotional effects on abductees convinced me that we were dealing with more than just hoaxes or psychological delusions. While such prosaic explanations undoubtedly accounted for some abductions, they could not account for them all," p. 276.

4 Interviewed by C.D.B. Bryan in his *Close Encounters of the Fourth Kind. A Reporter's Notebook on Alien Abduction*, UFOS, and the Conference at M.I.T. (Penguin, 1995) pp 260-263.

5 Jung p. 94.

6 "There are large mother-ships from which little UFOs slip out or in which they take shelter" (Jung, p. 11). See Orfeo M. Angelucci's shapely description of his Mothership in *The Secret of the Saucers:* "ike an 'igloo' or a 'huge misty soap bubble,' and inside there was 'a vaulted room 18 feet in diameter' with 'walls of ethereal mother-of-pearl stuff'" (Jung, p. 114). "The experience has a fetal aspect— abducted experiencers enter the hovering alien craft through a slit or other quasi-vaginal openings. Once inside the ship, whose interior is almost invariably dark, murky and warm, they are tested and probed . . . a kind of return to the womb. The experience is of helpless release, of surrender to something bigger than oneself." *Dreams of Millennium: Report From A Culture On The Brink* by Mark Kingwell (Faber and Faber, 1996) pp. 252-3.

7 While I sense a decade-skipping pattern, I also view the paradigm shift that UFO phenomenology requires as fitting into other decade-marked shifts:

 A-Bomb, Space Travel & Rock 'n' Roll 1947-57

 LSD & Anti-Millitarism 1967-77

 AIDS & Deconstruction 1977-87

 Cyberspace & Millennialism 1987-

As to the 70s phenomenon, see also my mention of Fleetwood Mac's 1973 "Hypnotised" and Frank Zappa's "Inca Roads" of the same year. As for Jefferson Starship's hippie, escapist "plan," it is enunciated in a number of songs from Kanter's 1970 *Blows Against The Empire*, particularly "Hijack":

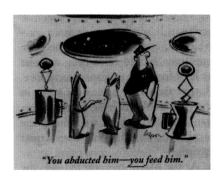

"*You abducted him—you feed him.*"

Cartoon from *The New Yorker*.

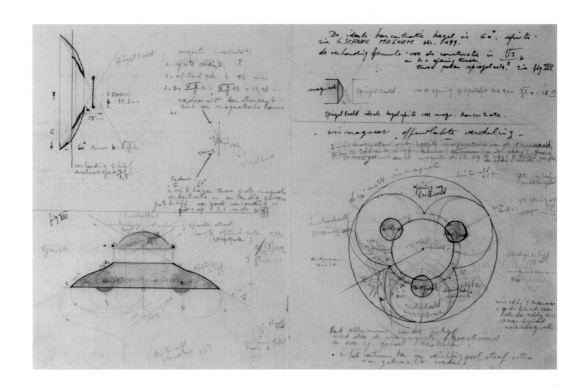

Above: Wake Eddy's, **Pencil, pen, and adhesive vignettes on paper, 1980.** *D. Panamarenko*, **by Hans Theys. 288 page cloth covered book, 1993.**

Left: Panamarenko, Magnetic Spaceship. **Scotch tape, pencil, collage on paper, 1978.**
Both courtesy Ronald Feldman Fine Arts, Inc., NYC

You know—a starship circlin' in the sky—it ought to be ready by 1990
They'll be buildin' it up in the air even since 1980
People with a clever plan can assume the role of the mighty
and HIJACK THE STARSHIP
Carry 7000 people past the sun
And our babes'll wander naked thru the cities of the universe
C'mon Free minds, free bodies, free dope, free music
the day is on its way the day is ours.
Words: Kantner, Slick, Balin, Blackman/Music: Kantner and "Starship."

Along these escapist lines, Jung writes: "It could easily be conjectured that the earth is growing too small for us, that humanity would like to escape from its prison . . . hydrogen bomb . . . population figures . . . Congestion creates fear, which looks for help from extra-terrestrial sources since it cannot be found on earth." p. 17.

8 Jung, p. 71

9 And it came to pass, as they still went on, and talked, that, behold, there appeared a chariot of fire, and horses of fire, and parted them both asunder; and Elijah went up by a whirlwind into heaven (2 Kings 2:11 KJV). Ezekiel's vision of four fiery wheels and multi-faced alien creatures runs throughout his first ten chapters: "And I looked, and, behold, a whirlwind came out of the north, a great cloud, and a fire infolding itself, and a brightness was about it, and out of the midst thereof as the colour of amber, out of the midst of the fire. . . . And the living creatures ran and returned as the appearance of a flash of lightning./ Now as I beheld the living creatures, behold one wheel upon the earth by the living creatures, with his four faces, etc." (Ezekiel 1:4, 14-15 KJV). Jodi Dean reports that at the 50th anniversary of Roswell —"UFO Encounter '97"—the Roswell museum lectures included the Church of Christ, "who featured alternative speakers testifying to the Christian message of abduction." *Aliens in America: Conspiracy Cultures from Outerspace to Cyberspace* (Cornell, 1998) p. 183. Jung calls man an "utterly dependent creature" (p. 53) who must "content himself with a prayerful yearning and 'groaning' in the hope that something may carry him upward" (pp. 54-55).

10 In a footnote on p. 86 of his "UFOs in Modern Painting" chapter, Jung reads van Gogh's *Starry Night* (1889) as a UFO painting: "There the stars are painted as large shining disks" by Van Gogh whose picture represents a "pantheistic frenzy," reportedly a "remnant of an apocalyptic fantasy." Van Gogh compared the starry disks to a "group of living figures who are like one of us." Two years prior to *Starry Night*, astronomer Giovanni Sciaparelli discovered remnants of water channels all over Mars and thereby began all of this speculation about Martian life on the Angry Red Planet. On June 21st 2000, scientists confirmed water, and hence very probably, life on Mars.

11 http://www.pbs.org/wgbh/nova/aliens/ *Nova On-Line*'s "Kidnapped By UFOs? Exploring the Alien Abduction Phenomenon." This excellent site contains interviews with three Believers—John Mack, John Velez, Bud Hopkins—and three Skeptics—Carl Sagan, Paul Horowitz, Philip Klass. We are warned: "This feature contains disturbing material." Artwork by John Velez is also presented.

12 Dean, p. 57.

13 Bryan, p. 257, 269.

14 *The New Inquisition: Irrational Rationalism and the Citadel of Science*, New Castle, 1995, p. 84.

15 Mack to Bryan, p. 270, 276.

16 Newitz, http://www.badsubjects-request@uclink.ucberkeley.edu." Quoted in Dean p. 168.

17 *Campaign Book Review*: http://us.imdb.com/Title?0045917, my emphasis.

18 "To my great interest, colleagues have jokingly referred to my own research as 'white trash studies'." Dean, p. 60. The white trash musical inculcation of the UFO phenomenon is surf music—witness the Spies Who Surf Lp *Calling All Martians* and the surfin' reverb-heavy Boss Martians Lps. Allow me to acknowledge here my debt to the airwaves of two local radio stations, and specifically the DJs of WESN's Dead Klown Show for playing Guthrie's "My Flying Saucer" and WGLT's Hillbilly Surf Hour for playing "Calling All Martians."

19 "Unfunky UFO" gets sampled by Ice Cube on *Dirty Mack*. Covers of "Mothership Connection" abound: Above The Law—"Pimp Clinic," Bitches With Problems—"Comin' Back Strapped," Dr. Dre—"Let Me Ride," Digital Underground—"Tales of the Funky," Eazy-E—"We Want Eazy," Infinite Mass—"Mah Boyz," Run DMC—"Groove To The Sound," Spice 1—"Young Ass Nigga," Sweet T—"On The Smooth Tip," Tone Loc—"The Homies," Yo-Yo—"Make Way For The Motherlode." Why are so many hip-hoppers attracted to this song? Joseph Thomas negotiates this hybridity as a mix of the raw funk with the intellectual: "Clinton coins the word Funkadelic, the term itself containing the tensions of carnival. Funk is ripe with earthy connotations: moldy, smelly. It also connotes unsophisticated, crude, natural. And the music funk is known primarily for low, repetitive bass sounds—the heavy kick drum on the one, the thump, the bottom, the groove. The delic side of the equation, however, comes from psychedelic. A quick etymology proves illuminating: the first mor-

pheme, 'psych,' is derived from the Greek *psukhikos*, meaning of the soul, or *psukho*, soul or life. The second, 'Delic,' is derived from *delos*, meaning clear and visible." After a brief analysis of the song "What is Soul," he continues: "The surprising and comic juxtapositions found (here) stress the bricolage that is their music . . . gospel elements combined with blues and rock and psychedelia." From "A Hamhock in Your Cornflakes," unpublished manuscript.

20 Jung,, pp. 46-7.

21 http://www.pbs.org/wgbh/nova/aliens/ *Nova On-Line's* "Kidnapped By UFOs? Exploring the Alien Abduction Phenomenon."

22 Jung, pp. 31 38, 34, 36. In a footnote on p. 19, Jung comments: "The obvious . . . translation into sexual language springs naturally to the lips of people. Berliners, for instance, refer to cigar shaped UFO as a "holy ghost," and the Swiss military have an even more outspoken name for observation balloons." The kinkier side to alien sex is manifested musically in the Kick Ass Martians song about cross dressing as an alien in order to cannibalize one's murder victim entitled "Silly Me": Let me say my little secret/Let me share what's in my head/The only reason that I tell you /Is that I know you'll soon be dead/'Gonna take off my glove /And show you my mutation/Doesn't matter what you think/'Cause to me you're mutilation/It's kind of funny /And strange what you do/When your murder victim's /All tied up right in front of you/'Gonna dress up like an alien /From a planet very far/Promise not tell a soul/When you're buried in my backyard/Do you like my poetry?/I guess you've had your fill/One more thing before you go/Did I mention I'm a cannibal?/It's kind of funny /And strange what you do/When your murder victim's /All tied up right in front of you" from *Hard Pop*, 1998.

23 Dean p. 60.

24 Quoted in Dean, p. 148.

25 Jung, p. 39.

26 Dean, p. 123.

27 *Nova On-Line's* "Kidnapped By UFOs? Exploring the Alien Abduction Phenomenon." http://www.pbs.org/wgbh/nova/aliens/john-mack.html

28 My emphasis. Intergalactic loneliness is at the heart of Kubrick's *2001: A Space Odyssey* and in the eerie mellotron and lyrics of Jagger/Richards' "2000 Light Years From Home" from the other-worldly Rolling Stones LP *Their Satanic Majesties Request*:"it's so very lonely, you're two thousand light years from home." E.T. needs to call and get home and many believers feel our home, Earth, has been broken into by alien perpetrators/trespassers.

66

29 What follows is a transcript of that improvised scene from Hopper's film followed by the lyrics to the Fleetwood Mac song:

Billy: Oh, wow! What? What is that, man? Wha-What the hell was that, man?

Wyatt: Huh?

Billy: No, man. Like, hey, man. Wow! I was watching this object, man—like—like the satellite that we saw the other night—right? And like it was just going right across the sky, man. And then, I mean, it just suddenly—uh—(laughs) it just changed direction and went—uh—whizzing right off, man. It flashed and—

Wyatt: You're stoned out of your mind, man.

Billy: Oh, yeah, man—like I'm stoned, you know, man. But—like, you know, I saw a satellite, man. And it was going across the sky—and it flashed three times at me—and zigzagged and whizzed off, man. And I saw it.

George: (Exhales) That was a UFO, beamin' back at ya. Me and Eric Heisman was down in Mexico two weeks ago—we seen forty of 'em flying in formation. They—they—they've got bases all over the world now, you know. They've been coming here ever since nineteen forty-six—when the scientists first started bouncing radar beams off the moon. And they have been livin' and workin' among us in vast quantities ever since. The government knows all about 'em.

Billy: What are you talkin', man?

George: Mmmm—well, you just seen one of 'em, didn't ya?

Billy: Hey, man, I saw something, man, but I didn't see it workin' here. You know what I mean?

George: Well, they are people, just like us—from within our own solar system. Except that their society is more highly evolved. I mean, they don't have no wars, they got no monetary system, they don't have any leaders, because, I mean, each man is a leader. I mean, each man—because of their technology, they are able to feed, clothe, house and transport themselves equally—and with no effort.

Wyatt: Wow!

Billy: Well, you know something, man? I think—you want to know what I think? I think this is a crackpot idea (Laughs). How about that (Laughs)? How about a little of that? Think it's a crackpot idea. I mean, if they're so—smart, why don't they just reveal themselves to us, huh—and get over with it (Laughs)?

George: Why don't they reveal themselves to us is because if they did it would cause a general panic. Now, I mean, we

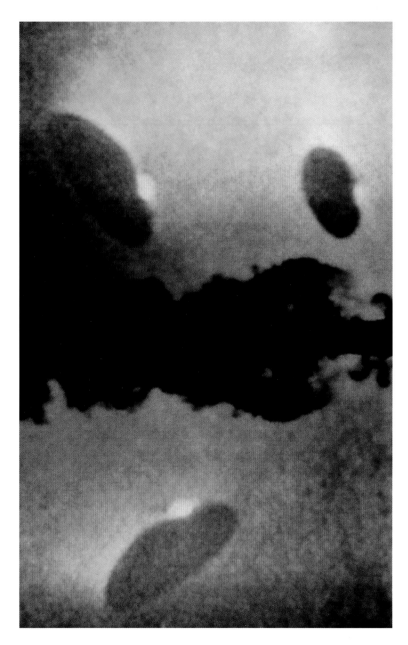

Oliver Wasow, Untitled #169 (detail). Iris print, 1986. Courtesy Janet Borden Gallery, New York.

still have leaders—upon whom we rely for the release of this information. These leaders have decided to repress this information because of the tremendous shock that it would cause to our antiquated systems. Now, the result of this has been that the Venutians have contacted people in all walks of life—all walks of life—(Laughs). Yes. It—it—it would be a devastating blow to our antiquated systems—so now the Venutians are meeting with people in all walks of life—in an advisory capacity. For once man will have a god-like control—over his own destiny. He will have a chance to transcend and to evolve with some equality for all. (*Easy Rider*. Screenplay by Peter Fonda, Dennis Hopper, and Terry Southern, Signet, 1969)

"Hypnotised" by Robert Welch (excerpts)
as Recorded by Fleetwood Mac from *Mystery to Me Reprise*, 1973.

Yes the same kinda story that seems to come down from long ago.
Two friends havin' coffee together when somethin' flies by their window.
It might be out on that lawn, which is wide, at least half of a playin' field.
Because there's no explaining your imagination can make you see and feel.
Seems like a dream, got me hypnotized.
(Your body means nothing, when you're hypnotized.)

Now it's not a meaningless question to ask if they've been and gone.
I remember of talk about North Carolina and a strange, strange pond.
You see the sides were like glass in the thick of a forest without a road.
And if any man's hand ever made that land well I think it woulda showed.

They say there's a place down in Mexico where a man can fly over mountains and hills,
And he don't need an airplane or some kind of engine and he never will.
Now you know it's a meaningless question to ask if those stories are right.
'Cause what matters most is the feeling you get when you're hypnotized.

Yeah that's when they got you hypnotized.
Seems like a dream, it seems like a dream.
When your body means nothing, you float around they got you hypnotized.

30 Angelucci's aliens infer that "man had not kept pace morally and psychologically with his technical development." Jung, p. 115. John Mack told C.D.B. Bryan that one of his contactees described the alien alarm this way: "It's like the butterflies coming back to stop the caterpillars that are denuding the bushes." Bryan, p. 274. This ecological message is pronounced over and over again in 50s and 60s UFO films, such as the *Angry Red Planet* whose Martian message "You have invaded our home" is delivered to the intruding Earthlings who they call "technological adults, but spiritual and emotional infants." This admonition is a stable element in most UFO abduction reports, whereby contactees are often shown "films" of future Earth ecological disasters. New Wave rock alien, Klaus Nomi, announces a similar jeremiad in his signature song, "Keys of Life."
31 Jung, p. 113.
32 "Now the rest of the acts of Josiah, and his goodness, according to that which was written in the law of the LORD, And his deeds, first and last, behold, they are written in the book of the kings of Israel and Judah." 2 Chronicles 35:26-7 "Yet now, if thou wilt forgive their sin— and if not, blot me, I pray thee, out of thy book which thou hast written. And the LORD said unto Moses, Whosoever hath sinned against me, him will I blot out of my book." Exodus 32-33. "O God. Thou tellest my wanderings: put thou my tears into thy bottle: are they not in thy book?" Psalms 56:7-8 "Let them be blotted out of the book of the living, and not be written with the righteous." Psalms 69:28.
33 "circular symbols have played an important role in every age . . . not only soul symbols but God-images . . . often associated with fire and light...round, complete, perfect..." Jung, p. 21
34 Interviewed for The Learning Channel's "UFO's: 50 Years of Denial" as part of TLC's "Alien Invasion Week," April 2000. Katharina Wilson believes "our government may in fact be trading alien technology for genetic material...or has chosen to look the other way." *The Alien Jigsaw* quoted in Dean, p. 119. Linda Moulton Howe speaks of a briefing paper that argues "these Beings have been genetically engineering us for thousands of years in order that we might achieve what importance we have achieved." Quoted from Bryan, p. 270. Thanks to Erich Von Daniken's 1971 *Chariot of the Gods* and the industry of books that have followed—*The Return of the Gods: Evidence of Extraterrestrial Visitations, The Eyes of the Sphinx: The Newest Evidence of Extraterrestrial Contact in Ancient Egypt, Arrival of the Gods:*

Ken Weaver, *Abduction Series: Eternal Return Variation 1.* **Oil on canvas, 1996. Courtesy Sixth@Prince.**

Revealing the Alien Landing Sites at Nazca—we have stories about aliens from the stone age who gifted early peoples with nearly every technological development humans might claim, from writing to building the pyramids, an alien astronaut preserved in a pyramid, ancient spaceflight navigation charts, computer astronomy from Incan and Egyptian ruins, a giant spaceport discovered in the Andes whose saucer left what Frank Zappa called "Inca Roads" (written in 1973) in his song of the same title from 1975's *One Size Fits All*—"Did a vehicle/Come from somewhere out there/Just to land in the Andes?/Was it round/And did it have a motor/Or was it something different?" 35 Jung, p. 114-17. One Howard Menger has reportedly sold records of music taught to him by the aliens. Dean, p. 40. There's quite a trove of alien inspired recordings "out there," that is to say, purchasable from your local record store and Internet. Here's a short list of some titles of interest: the alternative, electronic-super rock sounds of the KickAss Martians, Pauline Oliveros' *Alien Bog*, Margaret Brouwer's *Diary of an Alien*, Bill Laswell/Pete Namlook's *Psychic & UFO Revelations In Last Days*, Guided by Voices' *Alien Lanes*, Max Brennan's *Alien to Whom?* Alien Nation's *Hazardous Curves—Sesquipedalien*, Moody Alien's *Time Warp and Spaceshore*, Spectrum's *Forever Alien*, the alternative power metal grooves on the self-titled Lp by Clutch ("Escape From The Prison Planet," "Tim Sult Vs. The Greys," etc.), everything by Live Alien Broadcast, not to mention all of the alien-inflected songs on the X-Files inspired *Songs in the Key of X* (1996) and film soundtrack *The X-Files: The Album* (1998). Judging by those artists appearing on both of these collections, we can safely add Soul Coughing and Filter to those 90s UFO headliners Frank Black, the Foo Fighters, and surprisingly enough, Sheryl Crow. In keeping with my Afro-Mothership musical connection, a number of jazz/funk/fusion/R&B artists also seem to channel extraterrestrial-like music beginning perhaps with Shorty Rogers' 1957 jazz cut "Martians Come Back," and of course, with Sun Ra & His Solar Arkestra and His Myth Science Arkestra. Billy Preston kicks off the 70s funk connection with his top ten "Outta Space," which leads to Herbie Hancock's early 70s Headhunters' Sly Stone/George Clintonesque inspired funky fusion music with its futuristic synthesized electronica feel that attempts to be way "out there" and their 1998 reunion LP features natives getting zapped by a Headhunter UFO on the front cover and the more alien-"manned" saucers abound elsewhere. There's the L. Ron Hubbard sci-fideology behind the sci-entological jazz fusion of Chick Corea's Return to Forever band—particularly 1973's *Hymn of the Seventh Galaxy*, which includes the cut "Theme To The Mothership" and the hip, organ and moog-synthesized starship-escapist black jazz of Charles Earland's *Leaving this Planet* (one of my favorite jazz Lps with "monster" players Freddie Hubbard, Joe Henderson, et al) which features Earland on the cover of the Prestige vinyl (only—lost to CD cover miniaturization) Lp sitting in another planet's crater playing a circular three-tiered keyboard with an Easter Island-like head in front of him and an apocalyptic sky in the background. Along these lines falls the San Franciscan electric Miles trip-hop fusion music of Grassy Knoll, whose paranoid *Positive* Lp features the songs "Black Helicopters" and "Roswell Crash." Even Earth, Wind & Fire's 1977 zodiacal *All in All* contains a song called "Fantasy," that invites listeners to "Take a ride in the sky, on our ship Fantasii."

36 "The signal for UFO stories was given by the mysterious projectiles seen over Sweden during the last two years of the war—attributed of course to the Russians—and by reports of "Foo fighters," lights that accompanied the Allied bombers over Germany (Foo-*feu*)." Jung, p. 9. Dave Grohl and the Foo Fighters chose to cover Gary Numan's alien abduction saga "Down in the Park" for the Chris Carter/David Was 1996 Lp *Songs in the Key of X*, which includes, among many others, Frank Black's "Man of Steel" and Nick Cave's spooky tune about alien eugenics called "Red Right Hand." During the second season of "The X Files," Chris Carter heard "Red Right Hand" on an alternative LA radio show from his car radio driving home late one night and soon began to obsess over its "very ghoulish bass-line and mephitic lyrical imagery...I found myself cueing it up every time I sat down to write." The song appears in the two-part episode "Ascension." Note that like Buchanan & Goodman's 1956 "Flying Saucer," P.Funk (Wants To Get Funked Up)," the first cut on *Mothership Connection* is also an interrupted broadcast, interrupted by the funky aliens themselves:

"Good evening.
Do not attempt to adjust your radio, there is nothing wrong.
We have taken control as to bring you this special show.
We will return it to you as soon as you are grooving.
Welcome to station WEFUNK, better known as We-Funk,
Or deeper still, the Mothership Connection.
Home of the extraterrestrial brothers,
Dealers of funky music.
P.Funk, uncut funk, The Bomb.

Coming to you directly from the Mothership
Top of the Chocolate Milky Way, 500,000 kilowatts of P.Funk-power.
So kick back, dig, while we do it to you in your eardrums."

37 **From "Parry The Wind High, Low" on the LP** *Frank Black*:

"And if a ship meets your car /You know you can't go real so far / They could treat you real nice / Or put a tracking device / Way down inside / I'm checking out invention at the UFO convention tonight / … I'm getting patterns from a trekker and it sounds like soul records to me / … Patterns from a trekker, sounds like Desmond Decker to me / Sleep machine / In your silo / Transmarine / Things you've never seen." Other Frank Black UFO songs include "Bad, Wicked World" from *Teenager of the Year*: "Conquistadores that have been sent / Bad, wicked world / Bad, wicked world;" "Men In Black" from *Cult of Ray* "You believe it (you better) / I got their number / Classic camcorder / I saw everything / Dinner plate specials / The shapes of cucumber/ I'm going to the papers / I am going to sing / In the cool, cool night / And in the middle of the day / I'm watching my back / I'm waiting my visitation / From the men in black / Are they grey or is it my own nation? / It's been a good year / It's been a good summer / I wait for the door or that phone to ring / Our little race / I don't want to fail / So just in case / I made you a copy / And I put it in the mail / You believe it / I got their number / Classic camcorder / I saw everything."

38 **From Engineer Robert Moog's liner notes to** *Shirleigh and Robert MOOG present Clara Rockmore*, theremin, premiere artiste of the electronic music medium with Nadia Reisenberg, piano (Delos 25437, 1975). Note also the melancholy registered by the theremin—not quite that of its sister, the mellotron, but is evident in some of the literature contained in Ms. Rockmore's repertoire, such as Tchaikowsky's "Serenade Melancholique."

"Star Trek" makeup by Emmy winning artist, Brad Look at
The UFO Show opening reception.

My Ufology
Amy Wilson

I first started working with UFO and paranormal imagery about three years ago. It was an episode of the TV show "The X-Files" that really got me started; while I don't remember the specifics, there is one scene that has stuck in my mind since then. The skeptical, female FBI agent Dana Scully was sent to interview a rather awkward man in his early twenties about a UFO experience he'd had. He described to her how he went out night after night, looking for aliens, and lo and behold, this one night he had actually seen one. He described the rush of white lights and the whirring noise of the saucer lowering down upon him and declared that he had stood his ground, waiting to be taken aboard. To his story, the agent declared something to the effect of, "You must have been terrified!" to which the young man replied, "Well, you don't spend ten years playing Dungeons and Dragons without learning a little something about courage."

Roswell, New Mexico. Photo by Amy Wilson.

This rather strange exchange between two television characters on a show I had never previously watched has kept me interested ever since. It implied a fundamental truth to me about sociology, psychology, and consciousness at the end of the 20th Century: that there are people out there who are living lives so dull and unrewarding that their fantasies provide challenges to them that they would never otherwise experience. I suspect that this has always been true, but we live in an era where retreating into your secret fantasy world is more aggressively marketed and acceptable then ever before, with the proliferation of role-playing games, reality-based video games, and cyber-relationships/sex as just a few examples.

It also raised another interesting point to me: that in a time when nothing is presumed to be absolutely true, we are constantly encountering people whose version of reality is completely different than ours. Let me offer an extreme example—there are people on the fringes of even the most extreme conspiracy theorists who believe that our moon is actually a hollow, government-produced satellite, put into orbit to spy on us. Imagine how different those persons' world-view is from yours or mine, and how that notion would cloud every action and thought they would have. We have for some time accepted that there are differences in how people from different racial, ethnic and religious backgrounds view the world, but what happens when you belong to a sub-group that is so marginalized, so different, that only a handful of other people across the world subscribe to your shared ideas?

This idea is of enormous interest to me, and it is one of the most fascinating parts of ufology. Many people —perhaps even a majority of Americans—believe there is life outside of that on Earth. But finding common ground among those who do believe this is difficult, if not at times impossible. There are those who believe that life exists outside Earth, but that aliens have never traveled or made contact with us; there are those who believe that aliens have made contact through any of a number of ways (buzzing the skies with saucers, appearing to humans and giving them messages, etc.); those who believe that there is a secret pact between an alien race (or in some cases, many alien races) and our government, swapping their technology for the right to perform experiments on our citizens (there are many other reasons for the pact that are debated); and so on, splintering off into many other theories only more and more bizarre.

The astounding thing is that ufologists, by and large, swear by their theory and their theory alone, to the exclusion of all others. This of course makes research or even consensus building within those who agree on the larger issue impossible—a supporter of the once-government sponsored SETI program would never share information with an alien/government conspiracist (nor would the conspiracist accept any information from anyone aligned with a government agency—even if the government did de-fund SETI over two decades ago). This is no different from any other heavily studied field—there are fierce academic squabbles all the time—but when I first became interested in ufology, I rather naively thought that being so out on the fringes (without university or grant money to fight over, as well as very little prestige to go around) would force people to work together.

73

Berlin poster graffiti. Photo by Barry Blinderman.

In fact, there are many times when I think all UFO research would have just shriveled up and died had it not been for the infighting. Since it's not a field based on hard facts, what else is there? My current arch-nemesis is another artist-turned-ufologist, Budd Hopkins, who founded the Intruders Foundation, which is involved in alien abductee research. Don't get me wrong—I've never said a word to Budd in my life and I'm sure he has no idea who I am—but I just *hate* the guy. I showed up at one of his speaking engagements completely prepared for a showdown—to tell him off for once and for all—but chickened out and wound up pathetically sitting in the back row, rolling my eyes. Part of it is his arrogance (the web site for his Foundation must have his name plastered on it at least a dozen times), his wealth (in addition to making a nice living off of the UFO business, he lives in a fabulous—and probably rent-controlled—loft near Union Square in Manhattan while I rot away in Jersey City), and the fact that he

A MESSAGE.

A MIRACLE

WAITING FOR A SAVIOR
TO SWOOP IN FROM THE SKY
IS HARDLY ANYTHING NEW.

74

Left to right: Amy Wilson, A Message. Ink and gouache on paper, 1999.
A Miracle. Ink and gouache on paper, 1999.
A Vision. Ink and gouache on paper, 1999.
Research Begins. Ink and gouache on paper, 1999.

A VISION.

THE RESEARCH BEGINS WITH THE QUESTION, "WHY AND HOW DO PEOPLE MANAGE TO BELIEVE THINGS WHICH ARE PATENTLY FALSE?" SUCH A PERSPECTIVE HAS ITS USEFULNESS BUT IT IS NECESSARILY ETHNOCENTRIC IN THE MOST FUNDAMENTAL SENSE. IT TAKES A BODY OF KNOWLEDGE AND CONSIDERS IT TO BE SIMPLY "THE WAY THINGS ARE." RATHER THAN THE PRODUCT OF CULTURE. IT SAYS OVER AND OVER AGAIN: "WHAT I KNOW I <u>KNOW</u>, WHAT YOU KNOW YOU ONLY BELIEVE."

Budd Hopkins

seems so totally convinced of his research. I'd like to think that my anger resonates from his controversial use of hypnosis to "recover" forgotten memories from abductees—controversial because he's not a psychologist trained to handle whatever traumatic memories might surface, and also because "recovered" memories may not actually be based on fact—but it probably has more to do with that damn loft. In any case, my point is simple—if you're going to get seriously into ufology, you have to hate somebody, and if your reason for hating them is stupid and petty, then all the better. There has to be something in this field that becomes black and white for you (meaning: if I'm going to be a decent researcher, I have to always keep an open mind as to whether or not alien life really exists, but I don't have to keep an open mind about the fact that I fucking hate Budd Hopkins) or it will all spiral off into nothingness.

Having said all that, I find myself in a difficult situation. I've now completely written off Budd Hopkins, the Intruders Foundation, and most of alien abduction research, so whose theories do I subscribe to? The truth is that even someone with a good understanding of the field who is tempered by some outsider skepticism cannot point to one person and say, "He is qualified above all others to properly conduct the definitive research on UFOs in a trustworthy and responsible manner." Ufology has not become academicized—you can't major in it, can't become a doctor of UFOs—and since it seems to be a phenomenon that spans so many different fields, who is to say who is better qualified to study it—the housewife or the astrophysicist? Can I really hold it against Budd that he's an artist and not a psychotherapist? Ufology is the epitome of the punk rock/DIY ethos (another reason why it's so fascinating to me) where people become experts merely because they proclaim themselves to be, and anyone with access to a computer, the internet, and a xerox machine can easily promote his or her theory, no matter how outlandish or nonsensical it may sound. But still, all this stuff—the website, the books, the research—takes time. Budd is such a prominent figure in this field because he has paid his dues according the rules of ufology—he's done his research, he's written some books, he's toured the lecture circuit.

It's this notion of spending time that seems to glean the most respect from the UFO community. It's a huge claim to fame to be able to stand up at a MUFON meeting and say, "I've spent 30 years studying UFOs . . . " even if it's quickly followed up by "and I still haven't proven anything." I was by far the youngest person at a recent UFO symposium, and to say that I felt unwelcome as a result would be an understatement (the fact that I'm female didn't really help either, but that's another story). It seems strange that at a time in which UFO imagery and alien faces are plastered on t-shirts and notebooks, and movies/tv-shows like *Men in Black* and "The X-Files" are so popular that this would be the case, but it's true—the UFO community is aging to the point that within 20-30 years it will no longer exist. They seem completely uninterested in recruiting younger members, which to me defies all reason. But

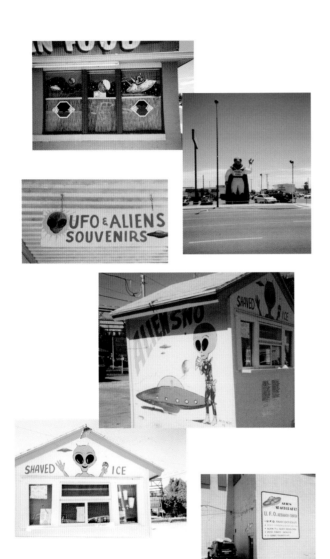

Snapshots from Roswell by Amy Wilson and Jeff Edwards, 2000.

of course, there is a reason—in a field where no one can point to anything concrete to show that they have accomplished anything, the only measure of worth is the time that they have put in.

So while everyone seems interested in proving that they've put grueling hour after grueling hour into pouring over UFO files, ufologists lose their grasp on the bigger problem: the fact that only a minority of them know how to do anything resembling professional research. As I stated before, I think it's admirable that ufology hasn't been academicized and that information is free and accessible to all, but there's a serious drawback to that. I'm reminded what a friend of mine who wrote extensively about punk once told me. To paraphrase him, the funny thing about punk is that you get into it because you fall in love with the idea that anyone can do it, but the more you fall in love and the closer you get to it, the more you disagree with that idea. Likewise, the closer and closer you get to a field that completely embraces the DIY ideal, the more you realize that maybe you can't do this all by yourself, that maybe you really need to bring in so-called experts to call for help. I can't get rid of the feeling that maybe we'd actually edge closer to understanding this field better if we started some standards for research—but then the idea of pushing out the housewives in favor of the astrophysists doesn't make me feel any more comfortable either.

There are at least some research standards that the majority of ufologists seem to agree on. When it comes to doing research citing previously written materials, they agree on two accounts: the government cannot be trusted, but anyone who claims to have been previously employed by the government who has decided to turn whistle-blower on its involvement in any part of

this field, must be believed. This constant rejection of sources that are generally considered reliable (although open to debate) and the acceptance of unnamed, uncheckable sources leaves the field open for constant ridicule from anyone outside of its immediate circle. Unfortunately, ufology is a mess, and I've only laid out some of the reasons.

Ultimately, ufologists are fanatics—I actually hate to use that word because it sounds so derogatory, but it's difficult to come up with another which describes a small band of people intensely dedicated to a viewpoint so outside the mainstream. For many of them, UFOs become their religion—it proves to them that there is something out there that is probably greater than they are—and like most religions, they have their own sacred ground. Most UFO experiences happen in open fields or dark roads late at night, and anyone who has dabbled in ufology will find it impossible to travel through these places without feeling a sense of awe. Trying to think of an analogy, I instantly thought of the way the Vatican is for Catholics, but then decided that this is too loaded—everyone knows that the Vatican is special to some group of people out there, even if they've never met an actual Catholic. The sacred ground to the UFO researcher is more obscure, more hidden than that. Rather, I think that Jimmy Page's purchase of Aleister Crowley's mansion in England is a more appropriate choice, and the way that thousands of people must past by it without realizing that it is considered the Mecca of Occultism. How many people drive home late at night returning from some party, without realizing that they are on sacred ground?

Aleister Crowley

By purchasing Crowley's mansion, Jimmy Page is able to surround himself with what he assumes is the most powerful representation of his beliefs. I would assume that every morning he wakes up in his home, Page feels his beliefs strengthened and acknowledged by the outside forces he believes in—he must feel as though he draws some power from his surroundings. This is where he and ufologists part ways, for while the open field at night is the ground zero for UFO sightings, it is also the site of a million failed experiments, of many evenings spent in vain, searching for something that the vast majority of them never find. Many ufologists have had some sort of strange, nighttime aerial phenomenon experience (seeing strange lights in the sky, for example), but few of them have had any of the intense experiences that fill up the most compelling UFO literature.

In fact, I have never heard of someone who has studied the field for a very long time—investing years of their lives tracking lights in the sky and attending MUFON meetings—only to be rewarded by a close

encounter of the third kind. Aliens seem to prefer appearing to people who did not previously believe in their existence—a nursing student, driving home after a late night at the hospital, is far more likely to have a saucer close in on her car that I ever will. The ufologist will arrive hours after the experience to interview the nursing student; in many ways, the highest reward for the researcher is the opportunity to hear second-hand stories. It almost as if becoming a ufologist is the surest way to guarantee that you won't see a UFO. The field is therefore stuck in a rut of personal failure—perhaps collectively, several researchers might draw conclusions that they consider to be an advancement, but individually they are no closer to the actual phenomenon then when they started; in fact, each day they spend requesting FOIA documents and interviewing witnesses must feel like a step further away from the experience itself. The sacred ground of the open field at night still represents the most likely place to have a UFO experience, but "most likely" is still stuck in the mode of "most likely not."

So, if seeing a UFO is the goal, and studying UFOs is the surest way to not see one, why study UFOs at all? Firstly, it's a little more complicated than that—it seems that not studying UFOs is only part of the deal you have to make with the cosmos to experience them firsthand—you also have to not believe in them (I've read countless interviews with people who have seen them, and they inevitably start out by saying, "I never believed in UFOs until . . . "). Naturally, if you don't believe in something, you don't really go around hoping to see it. But the second point is more important: by studying UFOs, you trade the minute chance that you might someday see one, for the sure bet that you will spend the rest of your days pondering thoughts and doing research on the kinds of information that otherwise would be completely hidden from you, information that is normally reserved for people with advanced degrees in a varied of fields (psychiatrists, astronomers, biologists, etc) which you most likely do not belong to. Everything negative that I have laid out about the field is also its greatest strength—the fact that I could go and publish a web site on astrophysics having never officially (academically) studied the field, means that I have access to information and to challenges that people who are not on the fringes don't. My web site might be—in fact, surely will be—riddled with inaccuracies, but do you think I would care? If I cared, I might go back to school and study the subject slowly and properly, but the truth is that this web site would not be for the kinds of people who cared about learning things "properly." UFO research is slap dash—see something in the sky, read Carl Sagan, look at *Paranoia* magazine, attend a MUFON symposium, publish your theory, gain supporters, argue with another theorist, etc., etc., etc. Ufology is a mess, but it's a glorious, populist mess, nearly utopian in its acceptance of newer and stranger beliefs.

Why? Because I suspect that deep down, all ufologists understand that this field is unknowable. Until such time as aliens appear on the 6pm news and proclaim that they are here and we are their slaves, there can really be no evidence to either prove or disprove their existence. We live in a time when information zooms past us at an amazing rate, where we know more about the world than any past

civilization ever could. If a disaster strikes halfway across the world, television cameras are there instantly to bring us the story in every detail. It's nice to know that there are still some questions that can't be answered. Whenever we need to feel as though we should be humbled—not only as individuals, but as a species—all that is necessary to do so is walk in a field at night. Looking up into the yawning, silent sky, we can picture hundreds of civilizations that have evolved way past our scrawny one, and imagine that they have all sorts of plans for us. Belief in any kind of organized religion might be a little too much for a supposedly jaded artist like me, but advanced alien civilizations? No problem—I can make that leap. I know it sounds absurd, but work with me—there they are, out there, flying around in space ships; they want to find you as badly as you want to find them. Go on—go out into that field near your home tonight and look up into the sky and imagine them out there. Isn't it great?

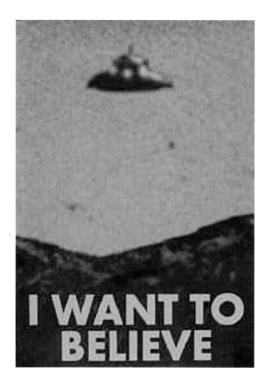

Poster appearing above Agent Mulder's desk on "The X-Files."

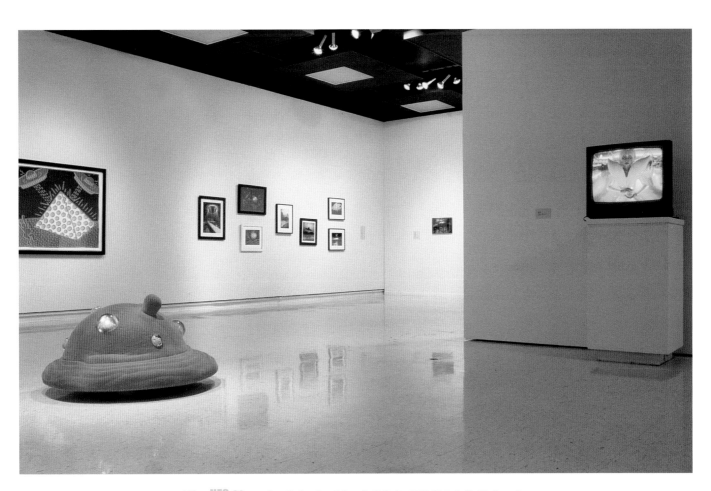

The UFO Show, Installation view. University Galleries, 2000. Photo by Karl Rademacher.

Ufology

from "Another Nut?"—Chapter 1 of *Saucer Wisdom*

Rudy Rucker

In the1950s there was a widespread feeling that the saucers were here to bring some kind of solution, perhaps to the then-paramount problem of the Cold War. As the great thinker Carl Jung wrote in 1958, "The UFOs . . . have become a living myth. We have here a golden opportunity of seeing how a legend is formed, and how in a difficult and dark time for humanity a miraculous tale grows up of an attempted intervention by extraterrestrial 'heavenly' powers"[1]

Flying Saucers by Carl Jung

For Jung, the circular UFO is a mandala symbol, representing an integration of the individual psyche with the forces of the cosmos. The flying saucer is thus a projection of the human desire for wholeness and unity. This insight of Jung's is simple and deep. The fact is that it makes people feel good to look at images of flying saucers. There is a feeling of safety and completion in these round, hovering entities.

These positive feelings are undoubtedly connected to our very earliest life experiences. Look back to the dawn of your life, back when you were part of—or nearly part of—your mother. Your mother's breast is the very first "round, hovering entity" that you encounter. Your mother is the original whole of which you were a part. The common use of the phrase "mother ship" for large UFOs is no accident.

In a healthy adult, the striving for wholeness is quite different from a return to the womb. Rather than longing to regress to infancy, we try instead to become capable of being parents ourselves. By an outward expansion of knowledge and compassion we become well-rounded, we learn to encompass multitudes, and if we are lucky we become parents or teachers who nurture and foster the young. On might say that in attaining emotional maturity, we *become* a womb rather than trying to reenter it. But this biological formulation leaves something out.

At the deepest level, our ultimate parent is the universe, or the God that underlies it. In maturing, we strive to become more at one with this pervasive divinity, to grow closer to the great ground of all being. This is a quest that is inherently religious, although "religion" can mean a pure spirituality rather than the adherence to the teachings of any particular human sect. And, as with the womb, the drive is not to annihilate oneself back to zero, but rather to expand one's circle of compassion out towards the infinite. In the words of the philosopher Blaise Pascal, the cosmos is a "sphere whose boundary is nowhere and whose center is everywhere."

In this connection, there was an interesting bit in the very first episode of "The X-Files." A poster in Mulder's office shows a picture of a flying saucer. And beneath the picture is the caption: "I want to believe." [see page 83] If we have a deep need to believe in something whole and integrated, what better symbol than a disk in the sky?

Another aspect of the roundness of the flying saucer is that it corresponds, as Jung remarks, to the shape of a mandala. Mandalas are diagrams that people in every culture spontaneously use to represent the geography of the psyche. It is customary to organize a mandala by placing opposing forces at opposite sides of the circle. The very simplest mandala of all, the yin-yang, pairs up paisley-shaped teardrops that are variously colored black-white or red-blue. The points of the compass form a familiar four-sided or eight-sided mandala. The zodiac, or wheel of the months, makes up a twelve-sided mandala. Contained within the geometry of the mandala are three key principles: The first principle is that any force has an opposing force. The second principle of the mandala is that any one axis between a force and its opposition can be transcended by looking at some other axis. For example you can move beyond an east-west conflict by thinking about a north-south synthesis. The third teaching of the mandala is that a state of complete balance involves an awareness of all the forces along all the axes. If the celestial saucers are harbingers of wholeness, it makes perfect sense for them to be shaped like mandalas.

Saucer Wisdom
by Rudy Rucker

Jung noted that the sexual instinct and the drive for power readily tend to obscure the reality of the quest for wholeness. As he puts it:

> The most important of the fundamental instincts, the religious instinct for wholeness, plays the least conspicuous part in contemporary consciousness because . . . it can free itself only with the greatest effort . . . from contamination with the other two instincts. These can constantly appeal to common, everyday facts known to everyone, but the instinct for wholeness requires for its evidence a more highly differentiated consciousness, thoughtfulness, reflection, [and] responsibility The most convenient explanations are invariably sex and the power instinct, and reduction to these two dominants gives rationalists and materialists an ill-concealed satisfaction: they have neatly disposed of an intellectually and morally uncomfortable difficulty . . . [2]

During the 1980s and 1990s, this is exactly what happened to ufology. The notion of wholeness was supplanted by notions of sex and power, and the UFO stories became accordingly unwholesome and paranoid. On one hand, the mythos was tainted by concepts relating to society's pervasive, icky con-

cern with sexual molestation and the politics of repro-
duction. And on the other hand, much of the energy of
ufologists has been diverted into infantile fears that an
all-powerful government has been hiding saucer contacts
from us. Just as Jung warned, concepts of sexuality and
power have utterly eclipsed the concepts of higher con-
sciousness.

Let me give you some quick examples of the role of sex
in modern ufology. Although Whitley Strieber's
Communion: A True Story is in some ways an interesting
book, it prominently features an alien proctoscope. "The
next thing I knew I was being shown an enormous and

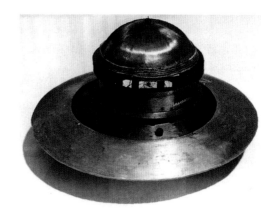

Panamarenko, **Adamski Saucer.**
Metal, magnets and wire, 1981. Private collection.

extremely ugly object . . . at least a foot long, narrow, and triangular in structure. They inserted this
thing into my rectum." Sadly enough, this repellent scene seems to have struck a deep cultural reso-
nance. Many more examples of this nature are to be found in the hypnotically evoked case studies
described in John Mack's *Abduction: Human Encounters with Aliens* (New York: Charles Scribner's
Sons, 1994).

What are Mack's abduction scenarios like? Much of a dreary muchness. You're in bed or in a car, usu-
ally asleep. You see a light. You float up into the air and into a flying saucer. Inside the saucer a tall
alien who reminds you of a doctor probes at your genitals and sticks things up your butt. If you are a
man, the "doctor" masturbates you to joyless orgasm, and if you are a woman, the "doctor" extracts
eggs from your ovaries. Then you wake up back in your car or in your bed. Is this pathetically infantile
scenario really what one might expect superhuman aliens to do? Would godlike beings fly halfway
across the galaxy simply to perform what Mack calls "urological-gynecological procedures"?

Modern ufology's obsession with political power is equally inane. Book after book appears about
alleged government cover-ups. One of the reasons for the success of the 1996 film *Independence Day*
is that it gave such a satisfyingly vivid depiction of what has become more and more of a core belief:
the U.S. government has several intact flying saucers in its possession, as well as some alien corpses
and even a few live-alien saucer crew members. Mesmerized at the thought of so vast a political con-
spiracy, today's ufologists engage in a never-ending discussion of amateurishly forged "top-secret gov-
ernment documents" that supposedly describe high-level contacts with aliens. How sad that in the
1990s a close encounter is likely to be with Xeroxed pseudo-bureaucratic gobbledygook—instead of
with a flaming wheel from the sky.

84

What has happened in contemporary ufology is that sexual fantasies and conspiracy theories have clouded over any possible higher truth in the UFO experience. Where we might have hoped to find creative ideas and enlightenment, we find only cliches and hysterical fear.

One of my main aims in setting *Saucer Wisdom* before the public is to try and alter this trend. Thanks to my contacts with Frank Shook, I'm in the fortunate position of being able to present a radically new style of ufology, which includes a great deal of completely new information about aliens and future worlds. I hope you enjoy Frank's tales as much as I have.

Notes

1 C.G. Jung, *Flying Saucers: A Modern Myth of Things Seen in the Skies* (Princeton: Princeton University Press, 1978), 16-17. (Originally published in 1958)

2 Ibid., 38

3 Whitley Strieber, *Communion: A True Story* (New York: William Morrow, 1987)

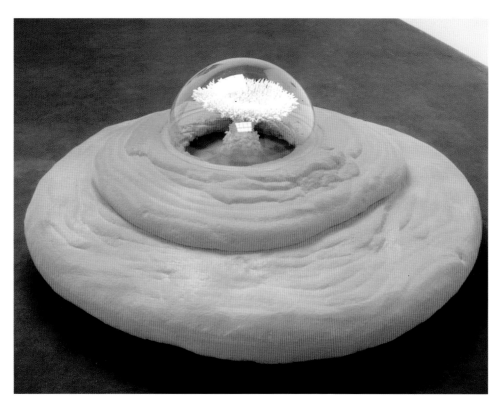

Jeremy Kidd, Pheranoid. Foam, coral, acrylic flocking, 1998. Courtesy the artist

Paratime
from "Frank Shook Time"— Chapter 2, *Saucer Wisdom*
Rudy Rucker

"So, where to begin?" said Frank.

"Let's start with the aliens," I suggested, setting out my fountain pen and my paper. I like to use a good pen; it's a writer's little extravagance. The paper was an ordinary pad of blank unlined paper that I'd gotten from school. "What is it like when you see them?"

He smiled nervously. "I'm still getting used to the idea of telling you about this." His Adam's apple bobbed.

"You've never told anyone?"

"Oh, I've told lots of people, but never a scientist like you. A skeptic. Someone who's going to try and analyze the hell out of it. If I tell the average person in San Lorenzo that I've seen aliens, they're not all that excited. Usually they say they've seen aliens, too. But when I listen to their stories, I can tell that they only imagined it. I only know one other person who sees aliens like me. Peggy Sung. She's this very grasping, materialistic woman who lives just down the road in Benton. But for God's sake, let's not start in on her."

"So tell me how it is when you see the aliens."

Frank took a deep breath, looked around the room, exhaled. "Time stops. And they appear. I have my adventures with them, and then they put me back where I started and time starts up again."

"Time stops? Does anyone else notice?"

"My wife Mary can tell when it happens, but you probably wouldn't be able to. There's a tiny little glitch in the continuity, but you have to know how to look for it. They could come for me right now. I'd just be sitting here with you aaand—" He moved his right hand slowly through the air "—time would stop and I'd go away and then I'd be back here finishing up my sentence. At least I might finish my sentence. If I happened to remember what I'd been talking about. Which is not at all that likely. Some of my adventures are real doozies."

"I don't get what you mean. If time stops, then how can anything happen?"

"Time doesn't stop for me. The aliens can make my time axis run perpendicular to regular time. We get into what I call paratime. Here, let me draw you a

Figure 5: **A History of Paratime**

picture." He took my pen and began to draw on my pad. "Think of all space as a point, and think of human time as the line going up the page. Now suppose that at each instant of our time you can find a different time direction that goes off at a right angle. A perpendicular paratime axis for each moment of human history."

Just then the food arrived. Frank kept right on drawing, adding more and more detail, moving the pen with an easy, practiced hand. While I watched him, I began to eat. My chicken soup was thick with meat and vegetables; the salad was fresh and well-dressed. I was enjoying myself.

"What are all those little drawings?" I asked Frank.

"Those are different ways that people have become aware of paratime," he answered. "The closest thing our planet has to cavemen today is the Australian aborigines. And the aborigines have this thing they call dreamtime. A timeless time that's outside of history. I figure that's paratime. Same thing for the Egyptian pyramids. A pyramid is a kind of time machine, isn't it? And in the Bible where Jesus tells the good thief, 'Today you will be with me in Paradise,' that's His way of talking about paratime. And that medieval mystic Meister Eckhart, he was totally into paratime. All of Man's time is one Now. It's everywhere, if you know how to look."

"Were you already thinking about paratime before you met the aliens?"

"Oh yeah! I've always been able to step out into paratime. A little bit, anyway. I used to be so dumb" Frank chuckled and shook his head. "I used to think that it was just me zoning out. But really I was having flashes of perpendicular time. Of course, it wasn't till the aliens started coming for me that I really got anywhere with it." He turned his attention back to his drawing. "The aliens first noticed Earth after we set off the first atom bomb in 1945. They saw the radiation pulse, and they started coming here, and now they're all up and down Earth's timeline."

"I don't want to sound like I'm hassling you." I said after studying the picture for another minute. "But what you've drawn here looks like two-dimensional time. One regular timeline plus a perpendicular time direction you call paratime. How do we get to that three-dimensional time you were promising me?"

Frank nodded, took a few bites of his enchilada, and started a new picture. "Yes. The thing is, Rudy, I simplified my picture so that you could understand it. Of course, there isn't just one direction of perpendicular time, there's lots of them. Has to be. Because when a saucer goes forwards and backwards through

87

Figure 2: **Paratime Prevents Worldline Crossings**

paratime, there has to be at least three dimensions of time to keep the saucer from running into its past self." He finished the sketch, tore the page off my pad, and passed it to me.

"I see, " I said. "And you're saying the aliens can do time travel?"

"Oh, yeah, that's one of the main things we do when they abduct me. We go and look at the future, even though we always stay right here in California. It's a funny thing how we never go anywhere else. The thing is, traveling across space is as big a hassle for the aliens as it is for us. An inch for us is an inch for them, a trillion miles is a trillion miles. And even the aliens can't go any faster than light. But once they actually get somewhere—like the Bay area— they're free to explore the place's whole history. They can visit the past and the future. Going forwards and backwards in time is easier for them then flying to a new place."

"So not only can they stop time, they can jump into the past or the future," I said. "Can you tell me any more about how that works?"

Frank began another picture, talking all the while. He was getting really excited. "The way that the aliens stop time is that they hover at one moment of our time by circling around that instant in higher-dimensional time, see. Like a corkscrew or Slinky." He handed me a drawing and started on the next.

Figure3: **Stopping Time with Paratime**

"And when the aliens want to look at our future, they get there by using a shortcut: they take a straight line through paratime that skips over our zigzags. I didn't mention the zigzags yet, did I? Earth's timeline is as shaky as a hound dog sniffing out a rabbit track. Because of quantum mechanics. Earth's time is so crinkly that a thousand years of it is only a few minutes across in paratime; it's like the way you can stuff a quarter-mile of kite string into your pants pocket." The new drawing was already done.

"I like this, Frank." A big smile had crept onto my face. "Though, of course, I don't really believe you. Are you a scientist?"

Figure 4: **A Paratime Shortcut**

"Not really. I took physics in high school. I didn't go to college. I watch "Cosmos" and the *National Geographic* specials on TV. And I've read some books. Bertrand Russell's the *ABC of Relativity* and Lancelot Hogben's *Mathematics For the Million*—ever hear of them? And I read a book called *Quantum Reality*—I forget the author—it has two globs like a figure eight on the cover. And of course, there's your book, *The Fourth Dimension*. It's a gas to be talking science with you, Rudy. Though, to be honest, the closest I come

to any in-depth technical knowledge is in the area of VCR players and video cameras. Which is how I met the aliens"

<center>🍄 🍄 🍄</center>

"I didn't tell you everything about paratime yet," Frank said as we waited for the change. "Your mind can come unstuck from the human timeline and move around in paratime. I think dreams take place in paratime. That's why so many people dream about seeing aliens. Like human time is a big kelp stalk and the aliens are fish floating next to it."

He picked up my fountain pen, tore the last drawing off my pad of paper and started to draw a new picture. I tucked the finished drawings into my briefcase.

"Actually, I think of the saucers as hummingbirds," Frank was saying. "Like a hummingbird sipping nectar from a bottlebrush flower."

A bottlebrush, I should explain, is an introduced Australian plant common in California. Its large red flowers are cylindrical spikes with densely-packed radial stamens arranged like the bristles of the kind of brush you'd use to clean baby bottles.

89

Figure 5: **Hummingbird Alien**

"The alien saucers fly in and out along perpendicular paratime axes to keep probing into the world," continued Frank, still drawing. "But since the world's time is so folded and wadded-up, the aliens can pretty much just turn their beak a little bit and probe into the past or into the future."

"You keep talking about flying saucers," I said. "Are you really telling me that the aliens come in physical metal machines?"

"The saucers aren't machines, they're energy. Of course, energy can look like matter. Einstein says, eh, Rudy? And matter can look like a machine. So anything's possible."

<center>🍄 🍄 🍄</center>

Illustrations by Rudy Rucker.

🍄 🍄 🍄 denotes deleted passages

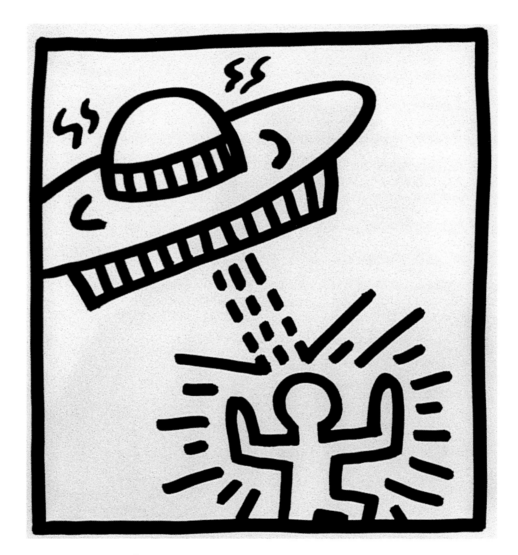

Keith Haring, Untitled. Felt-tip marker on paper, 1982. Courtesy of Tony Shafrazi Gallery, New York.

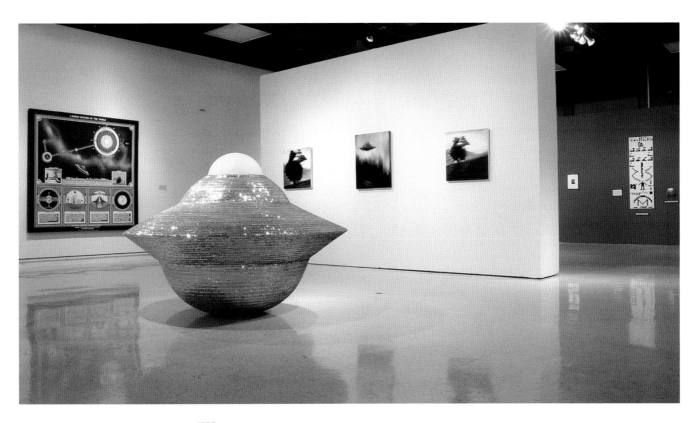

The UFO Show. Installation view at University Galleries, 2000. Photo by Karl Rademacher.

We Believe
Carlo McCormick

Extraterrestrials, flying saucers, other worlds, intergalactic travel, alien visitations, abductions, seductions and psychosexual anatomical probes. Angels, space invaders, pod people, Chicken Little, Heaven's Gate and the prophesy of Scientology. We believe in so many things. Much like Atlantis and a living Elvis, we believe in what we cannot see but on the periphery of our imaginations, where desire, dread, the hallucinatory optics of faith, the spectacle of showbiz huckersterisms and the collective iconography of archetypal myths form a void of reason where all is possible. It is there, in the deep space of our mind's eye, where we can conjure and glimpse the enigmatic promise of the last true Other.

We believe, most particularly, because it is our national psyche to do so. The bizarre hybrid of science and fiction where space ships and quasi-humanoid ETs exist in utter suspension of belief is in fact a

Members of the New Age Foundation join hands to create a "cosmic brain battery" to summon UFOs to land at the twentieth annual New Age Convention, Mount Rainier, Washington.

Cynthia Roberts, Departure, Oil and silkscreen on canvas, 1998. Courtesy Tricia Collins Contemporary Art, New York.

94

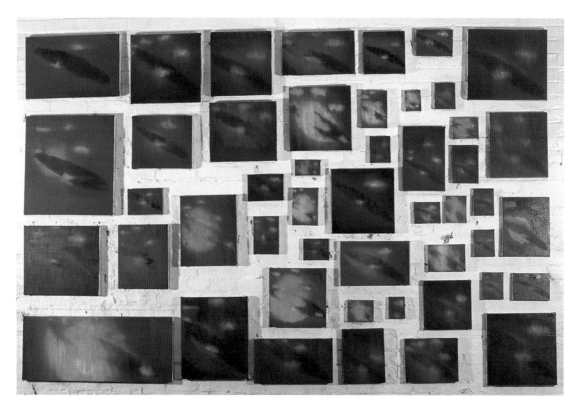

Above: Joy Garnett, Massive Attack. Oil on canvas, 1997. Courtesy the artist and Debs & Co., New York.
Below: Massive Attack (installation view). Oil on canvas, 1997. Courtesy the artist and Debs & Co., New York.

Video stills from Alien Autopsy, 1996.

very American place indeed. The locus of Science Fiction as a genre, from its origins to its continued evolution, belongs almost exclusively to the United States. And be it The Great Airship Mystery of 1896, or the first sighting of flying saucers over Mount Ranier in Seattle by Kenneth Arnold in 1947, it does seem that America is the first and foremost popular tourist destination for alien visitors. Perhaps in the logical extension from car to rocket ship to UFO, we are the perfect place for all such pre-pubescent male fantasies. Do we not still even delude ourselves today that here is where the visions of the future can be realized, without historical continuum, as imagined by youth? And then, all the while we dream, these fantasies themselves become increasingly imbued with the darker shadows of the millennial zeitgeist.

It doesn't matter really what Arnold saw, not to Seattle which has always taken a special pride in being the place where we made our first speculative contact, nor especially to the rest of the nation where such news touched off one of the most enduring and pervasive folkloric fantasies of the modern era. There were in fact more than eight hundred subsequent sightings scattered around the country in the months following. And what ultimately most startles the rationalists and skeptics amongst us is that by all counts the vast majority of Americans believe in UFOs. Does it matter, then, that: George Adamski, who did so much to popularize and cash in on this phenomenon with national slide lecture tours of his contact with Venusians in the early Fifties; or Erich Von Daniken, whose 1968 best seller *Chariot of the Gods* postulating a revisionist history whereby aliens created mankind and civilization sold more than five million copies; or Robert Spencer Carr, a Fifties hack SF writer who made up the entire conspiracy theory of aliens being held in cold storage at Wright Patterson Air Force Base in Dayton, Ohio; or even H. G. Wells, who stunned the nation into panic with his 1938 *War of the Worlds* radio broadcast of alien invaders—all turned out to be spinning elaborate hoaxes? Certainly not. As we continue today to speculate on crop circles, alien autopsy footage, television re-enactments, we all by now seem to know that the truth really doesn't matter in such things. UFOs are a very social art form, a form of cultural narrative that, much like any act of faith, assert the fundamental tenet that belief itself is simply enough. It is all a supreme art of self-delusion that takes a secret pleasure in positing a post-rationalist quasi-mystical faith when we actually know better. This is as true of the way audiences world- wide view blockbuster movies like *ET* and *Independence Day* as it is of how the artists collected here approach the subject of UFOs.

As an aesthetic topography, the vision of UFOs has had a mass populist impact and a proven ground of creative fertility via the same sort of pictorial strategies and phantasmagorical possibilities as Surrealism. Basically, we like them because they inhabit that realm of the subconscious where deeper ulterior truths are made manifest and fantasies have the patina of actuality. They function at once as surrogates for the self-evident and collective truths of our more earthly realities, and as transcendental vessels for the best ideals and darkest doubts engendered in our uncertain relationship towards the unknown. As such, they are available to artists as archetypal clues to the kind of universal picture/message that has become a common point of investigation in the wake of Joseph Campbell's seminal study of myths. As much as he asserted that "we are concerned, at present with problems of symbolism, not of historicity," stories and myths are what now fascinate us, not their actuality. In any form of mass cultural hypnosis, the truth rarely matters nearly so much as what everyone believes.

The appeal of UFOs on our contemporary imagination is manifold. Open-ended signs with multiple meanings, they can stand in for any number of different considerations. UFOs can easily reference the dominant narratives of pop culture, where they most often reside, and this can itself run the range from pure celebratory camp to ways of opening up other sociological interpretations. They can be used as well to call into question the veracity of photographic authority. For others they function as the enigmas through which to pose spiritual and visionary interpretations. For some they even invoke the psychosexual mythos of alien abduction. The UFO may as well exist quite simply as a pictographic representation, a form of language or a primary shape open to formalist interpretation. For the artists represented herein, it might be a mistake to categorize their work according to any such model, as most embrace a number of these concerns in their incorporation of the UFO. And as much as their intentions extend beyond a single discourse, we must also consider that, like most of us, these artists confront the riddle of UFOs with a fair degree of ambivalence, alternately (or simultaneously) ironic and sincere, doubtful and believing, abstract and literal.

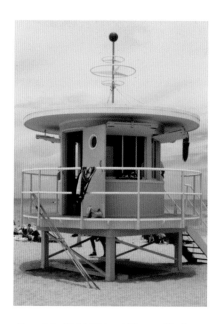

Kenny Scharf (with Bill Lane), **Lifeguard Project.** 1993, Miami Beach. Photo by Bill McBride.

As most of us have not in fact "seen" flying saucers and space ships, they exist for us most significantly as a set of media representations. In art as in the deepest recesses of imagination, they are not easily

96

Andrew Detskas, Forget SETI.
Mixed media, CD player, CD; 1999.
Courtesy the artist.

In the 1970s a program called SETI (The Search for Extraterrestrial Intelligence) was begun. This program utilized radio telescope technology to tune in, as it were, to possible artificial radio activity in deep space. Not only did SETI scan the heavens for signals, but also it sent some of its own. The graphic to the right represents one of these signals. Intended to be received by intelligent life elsewhere in the universe, the graphic was then intended to be interpreted by sight. The simplified imagery within the graphic represents subject matter such as binary encoding, elements of life on earth, a DNA strand, a radio telescope and a human form. (Can you see it?)

Ambitious as the SETI program is, combined the amount of knowledge culled from the data received since the 1970s are truly amazing. Yet several facts still remain, no artificial transmissions have been received. As for the transmissions we have sent, our generation will never see their possible answer because of the distance they have to travel. Furthermore, there is no guarantee that alien life, if it exists, would interpret this transmission visually. Human beings , having developed the sense of sight as its primary sense, are the work of millions of years of evolution. What if a similarly constructed life form developed differently? This could very well be the case. An alien life form evolves on a planet with its sensory acuity centered in its auditory system. A world absorbed by the intricate movements of sound waves.

separated then from all the myriad movies, TV shows, comics, novels and other story-telling forms where their facts and fictions are continuously traced. In painting and sculpture, for whatever else the fine artist brings to this subject, it is always somehow redolent of Pop. For many included here, such as Joy Garnett, Keith Haring, Lance Horenbein, Claire Jervert, Christopher Johnson and Kenny Scharf, the forms of visual communication or primary material sources are quite specifically pop cultural. Noting how Science Fiction itself has been usurped by the consumer marketing of science, Garnett explains "what interests me is how images from media and advertising

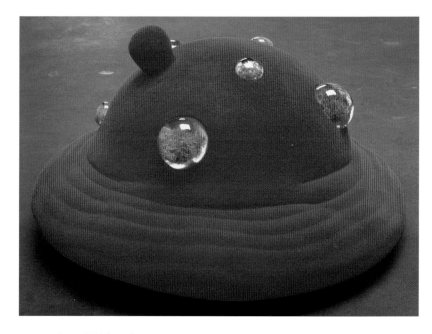

Jeremy Kidd, Organitron. Foam, acrylic flocking, resin, moss, 1998. Courtesy the artist.

get under people's skin." For Jervert, whose every image is lifted from television, her pictures may pay homage to the seductiveness of TV, but she ultimately views the screen for what it tells us about "perception, psychologically and culturally, and sociologically about us." Much of our pop cultural detritus continues to be appropriated as fodder for contemporary art, but not much of it is nearly so problematic or psychologically revealing as our fascination and fetish over these alien craft.

As part of the overlying pulp of pop, the flying saucer is very much rooted in a now-arcane vision of the future. No matter how many trekkies may subscribe to the fantasy of warp drive, or others may imagine traveling through deep space at faster than light speeds, we know enough about the relativist universe at this point to realize this is simply the stuff of dreams. As such, we must regretfully note that the future is not what it used to be. It is perhaps best deemed now as a point of bittersweet nostalgia. Belgian artist Panamarenko has made a brilliant career out of seducing us into believing such possibilities with his visionary sculptures of technologically elaborate flying contraptions, but it is Kenny Scharf who has wholeheartedly jettisoned the mundane laws of physics to reimagine the fantasy lore of yore. In love with the futuristic automotive, industrial and advertising designs of late Fifties and early Sixties America, Scharf admits that "we've all been let down—when reality hit in the Seventies, and we discovered that this futuristic vision was all a big lie, I continued it as my fantasy."

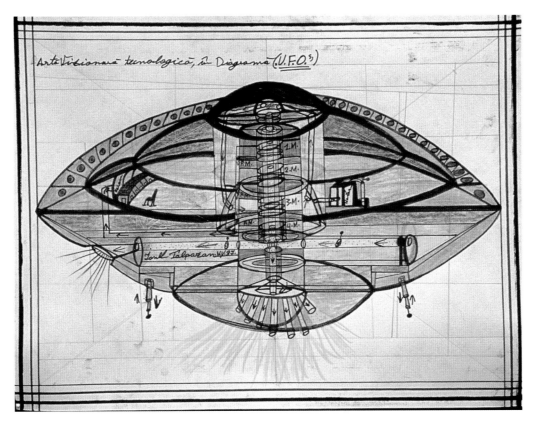

Ionel Talpazan, Propulsic Nucleara. Markers and pencil on paper, 1995. Courtesy American Primitive Gallery, New York.
Arta Vizionara. Markers and pencil on paper, 1997. Courtesy American Primitive Gallery, New York.

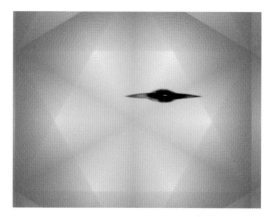

Clockwise from top left: George Blaha, Taken Out of Context, Pene-Umbra, From the Empty to the Void
Where the Mind's "I"s Moved. Ink jet on glossy film, 1999. Courtesy the artist.

As much as the UFO—since perhaps Ezekiel's Old Testament sighting of "glowing metal, as if full of fire" overhead—has been the province of mystical, visionary and fantasy experience, it serves today very much as a kind of mock-signifier for the persistence of gullibility and the devices of false persuasion working on our need to believe. As such it can be employed by Andrew Detskas as a primary pictographic language, or in the case of Cynthia Roberts, "a symbol for the non-specific, all the information you might need to come to this term that has no definition." And if our level of belief is very much dependent on how we read the evidence, it is the visual evidentiary language itself that must be called into question. John Brill can make abstract suggestions of some paranormal visitation, mimicking the look of UFO pictures by "selectively removing information in a very precise way," but as much as he may be seduced himself by the mystery, they directly question the veracity of photography. For Oliver Wasow, whose photo-based work comes directly out of postmodernist confrontations with photographic authority, his entry into digital culture (where faking is less an art than an inherent technical capacity) has rendered the urgency of such a discourse nearly moot. But rather than being entirely absent from his agenda, Wasow views irony now as "simply another notch on my vertebrae."

In the most basic of visual terms, the UFO is quite undeniably a wonderful form—streamlined, austerely stripped of ornament or specific identifying details, and hovering magically in that space where the above meets the beyond. The potential this offers for sculptors is tremendous. For Sharon Engelstein, the UFO is an "attempt to get at pure form—perfect, generic, familiar, streamlined, dynamic and organic." Jeremy Kidd came to this form less as a set subject than a remarkable discovery of process itself, uncovering some of the formal wonder that Engelstein sought to capture, and ultimately was seduced most by its conflation of "the synthetic and the organic."

Beyond all issues of art, language, culture and media, the potency of the UFO is its formation as a collectively witnessed apparition, a detected presence in the great void we've been trying to fill since the dawn of history. It is the hunger of SETI, and the wishful promise of deeply empiricist Carl Sagan's *Contact*. It is science confronting its demon and savior: the unknown, the godhead, the horrific absence of meaning it has engendered by nullifying the prevailing orthodoxies with its own limited logic. Where explanations run out, where the solitude of space gets so vast that we feel utterly alone, where the boundaries of the known meet the deep void of our cosmic insignificance, where science meets fiction and narcissism meets need—that's where you'll see flying saucers. They are not so much unidentified, as very loose identifications of what we do not know. A form of belief perfectly tailored for our materialist world, a quasi-mystical conception of the universe that allows for Darwin and the many other scientific absolutes accumulating before us, the UFO fits as easily into the complex cosmologies of Paul Laffoley as it does into Mariko Mori's pop distillations of religious tradition and Ionel Talpazan's outsider visions. Generic and endlessly suggestive, it appears in the work of George Blaha as the discrete fearful symmetry of phenomenology. It is a geometry in which he can divine "ancient

sacred architecture, Tibetan stupas and Buddha." Ever since the most stupid and frightened of living creatures managed to get upright, this ignorant beast called humanity has been looking to the skies, seeing gods, spirits, angels and deities. It only took the postmodern mind to fill in the constellations and myths, to stop calling it God and populate it with aliens.

The UFO is really just a vessel to carry all that psychic baggage we're too lazy and limp to lift on our own. Artists like Kenneth Weaver go so far as to populate them with the aliens themselves, provoking the darkest phobias and absurd obsessions of our abduction fantasies. Amy Wilson admits to being genuinely scared by this stuff, but is more "interested in the very strange, lonely people who believe in UFOs lock, stock and barrel." Indeed they are strange and lonely, but taken collectively they may in fact be the norm itself. These heavens, the out there, above, beyond and who knows what else, is the perfect Rorschach for us to project the full encyclopedia of dumb dread and wishful thinking. From the first official alien abduction story of Betty and Barney Hill in 1961, it's not so far a journey to erstwhile horror novelist Whitley Strieber's best selling "non-fiction" account of his own abduction in 1987's *Communion*. Nor, even, does history separate Swedish mystic Emanuel Swedenborg's fantastical description of the denizens of Mercury, Venus and other celestial bodies in his *Concerning Other Worlds* of 1758, from Robert Heinlein's *Starship Troopers* of 1958, recently made all the less real on celluloid, for while the former was nothing less than a transposition of the natives of the then New World (America), Heinlein's invading bugs (as smart and tough as we and wanting "the same real estate") are just another paranoid cold war glance back across those same waters.

We are indeed a superstitious lot, no less addled when we follow Marshall Applewhite and nurse Nettles—the woman he met when he went to a clinic to be cured of homosexuality back in the Seventies—in suicide to the kingdom of heaven promised by the Hale-Bopp comet to their Heaven's Gate, or listen to guru Shoko Asahara and his Aum Supreme Truth Shinrikyo cult and believe that the frequency of UFO sightings is certain evidence of impending Armageddon (and time to unleash sarin nerve gas on the Japanese subways), than we are in following L. Ron Hubbard in the logical step from the pseudo-science of Dianetics to the full blown religion of Scientology, where we are all descendants of extraterrestrial Thetans. Yes, we do believe.

Kenny Scharf, Chiki. Customized vacuum cleaner, 1983. Collection Min Sanchez. Photo by Karl Rademacher.

List of Works in the Exhibition

* denotes reproduced works
dimensions: height precedes width precedes depth

George Blaha

Pene-Umbra*
11 x 16 inches

From the Empty to the Void*
29 x 16 inches

Os
14 x 13 inches

Where the Mind's "I"s Moved*
15 x 21 inches

Unidentified Inner Phenomenon
11 x 13 inches

Taken Out of Context*
13 x 17 inches

All works ink jet on glossy film, 1999.
Courtesy the artist.

John Brill

Material Image AG38531*
15 x 16 inches

Material Image AH71151*
15 x 16 inches

Material Image SR09041*
15 x 16 inches

Material Image AH71552*
16 x 15 inches

Material Image BH00100*
19 x 18 inches

All works selenium-toned silver prints, 1991.
Courtesy Kent Gallery, New York.

Andrew Detskas

Forget SETI,* 1999
Mixed media, CD player, and CD
64 x 30 x 2 inches
Courtesy the artist.

Sharon Engelstein

Flying Saucer,* 1998
Sequins, foam, and plexiglass
54 x 72 inches diameter
Collection The International UFO Museum and
Research Center, Roswell, NM.

Sampler, 1998
Mixed media
18 x 22 inches diameter
Courtesy the artist.

Joy Garnett

Scud,* 1999
Oil on canvas
36 x 48 inches

Massive Attack,* 1997
20-painting installation, dimensions variable
Oil on canvas

Pulse, 1997
Oil on canvas
48 x 48 inches

All works courtesy the artist and Debs & Co., New York.

Keith Haring

Untitled (Fertility Suite),* 1983
Silkscreen ink on Rives BFK Paper
42 x 50 inches

Untitled,*1982
Felt-tip marker on paper
9$1/2$ x 8 inches

Untitled, 1982
Felt-tip marker on paper
9$1/2$ x 8 inches
Collection George Horner, Brooklyn.

All courtesy Tony Shafrazi Gallery, New York.

The Blueprint Drawings,* 1990
Silkscreen
42$1/2$ x 51 inches
Courtesy The Keith Haring Foundation.

Lance Horenbein

UFO,* 1995
Polaroid color print
14 x 11 inches
Courtesy Tricia Collins Contemporary Art, New York.

Claire Jervert

10/1998oz-1*

22/1998oz-2

3/1998oz-1

1/1998oz-1*

4/1998oz-1*

All cibachrome prints on honeycomb aluminum, 1998.
13 x 191/4 inches
Courtesy Steffany Martz Gallery, New York.

Christopher Johnson

Galena, Illinois, 1997
Oil on canvas
12 x 16 inches

Three Rivers, New Mexico,* 1996
Oil on canvas
20 x 16 inches

Route 20, Illinois, 1997
Oil on linen
16 x 20 inches

Rt. 97, Oregon (Mt. Shasta),* 1997
Oil on linen
18 x 26 inches

All works courtesy the artist.

Jeremy Kidd

Organitron,* 1998
Foam, acrylic flocking, resin, and moss

Pheranoid,* 1998
Foam, coral, and acrylic flocking

Both works courtesy the artist.

Paul Laffoley

The Urban Fossickated Octave,* 1968
Oil, acrylic, ink, and lettering on canvas
51 x 51 inches
Private collection, New York.

I, Robur, Master of the World,* 1968
Oil, acrylic, ink, and lettering on canvas
731/2 x 731/2 inches
Collection Peter C. Du Bois, New York.

Geochronmechane: The Time Machine from the Earth,* 1990
Ink and lettering on paper
32 x 32 inches
Private collection, New York.

The Thanaton,* 1996
Ink, lettering acrylic on board
23 x 23 inches
Collection Peter Giblin.

All works courtesy Kent Gallery, New York.

Mariko Mori

Miko No Inori,* 1996
Video, 29:23
Courtesy Gallery Koyanagi, Tokyo and Deitch Projects,
New York.

Panarmarenko

D. Panamarenko, by Hans Theys, 1993
288 page cloth covered book
161/2 x 12 x 21/2 inches

Pool: Ruchsachflug Furka Pass, 1991
80 page sketchbook
121/2 x 101/4 inches

Magnetic Spaceship,* 1978
Scotch tape, pencil, collage on paper
161/4 x 131/2 inches

Courtesy Ronald Feldman Fine Arts, Inc., New York.

Cynthia Roberts

Departure,* 1998
Oil, silver, and silkscreen on canvas
84 x 60 inches
Courtesy Tricia Collins Contemporary Art, New York.

Kenny Scharf

Chiki,* 1983
Customized vacuum cleaner
16 x 8 inches diameter
Collection Min Sanchez.

Ionel Talpazan

Teory UFOs, 1995
Markers and pencil on paper
15 x 18 inches

Diagrama and Teory,* 1996
Markers and pencil on paper
8 1/2 x 11 inches

Propulsic Nucleara,* 1993
Markers and pencil on paper
8 1/2 x 11 inches

Orange UFO Diagram, 1995
Pen and markers on paper
10 x 8 inches

Courtesy American Primitive Gallery, New York.

Oliver Wasow

Untitled #326, 1998-1999
Digital cibachrome
27 x 23 inches

Untitled #296, 1994-1995
Cibachrome print
18 x 26 inches

Untitled #312, 1996
Iris print
18 x 22 inches

Untitled #169,* 1986
Cibachrome print
21 x 17 inches

Untitled #264, 1986
Cibachrome print
18 x 22 inches

Untitled #164,* 1987
Cibachrome print
17 x 21 inches

Untitled #107, 1983
Cibachrome print
17 x 21 inches

All courtesy Janet Borden Gallery, New York.

Ken Weaver

Abduction Series: Alien Theatrics, Var. 3
Abduction Series: Eternal Return Var. 4*
Abduction Series: Alien Theatrics, Var. 1*

All oil on canvas, 1998.
Courtesy Sixth@Prince, New York/Paris.

Amy Wilson

A Vision*
6 x 9 inches

A Miracle*
9 x 6 inches

A Message*
6 x 9 inches

I Want to Believe*
9 1/2 x 13 inches

I Will Be Your Receiver*
14 x 10 1/2 inches

All watercolor on paper, 1999.
Courtesy the artist.

Acknowledgements

I am deeply indebted to the following artists, gallerists, curators, collectors and other individuals who generously shared information, insights, artwork, readings, videos, and photographic materials for this project: Dan Addington at Gwenda Jay/Addington Gallery, Michael Amaral, Aarne Anton at American Primitive Gallery, George Blaha, Tricia Collins Contemporary Art, Rob Conrad, Debs & Co., Deitch Projects, Andrew Detskas, Kelly Donovan, Peter C. Du Bois, Sharon Englestein, Ron and Frayda Feldman, Joy Garnett, Peter Giblin, Jeff Gleich at Sixth@Prince, George Horner at Tony Shafrazi Gallery, The Keith Haring Foundation, The International UFO Museum and Research Center, Roswell, Claire Jervert, Christopher Johnson, Jeremy Kidd, Paul Laffoley, Steffany Martz, Tom Moody, Tim Porges, Cynthia Roberts, Lauren Ross at White Columns, C.K. Sample, Min and Ollie Sanchez, Michael and Stanley So, Douglas Walla at Kent Gallery, Inc., Oliver Wasow, Ken Weaver, and Amy Wilson.

The creation of this book was largely dependent on essays written specifically for The UFO Show by: cultural theorist Bill McBride, artists Amy Wilson and Paul Laffoley, and critic Carlo McCormick. I am particularly grateful to sci-fi novelist Rudy Rucker, who agreed to let us reprint excerpts from his recent book *Saucer Wisdom*, and also contributed "A History of Ufology," which has not been previously published.

I would also like to thank my colleagues whose museums are participating in The UFO Show tour: Malinda Chadsey, Curator of Exhibitions at The Arts & Science Center, Pine Bluff, Arkansas, and Gerry Riggs, Director of the Gallery of Contemporary Art, University of Colorado at Colorado Springs.

107

My talented staff worked tirelessly throughout the development and realization of this project: Bill Conger, Curator, engaged in his own "sightings" research, landing us Ken Weaver, Mariko Mori, Panamarenko, and Ionel Talpazan, besides engaging in the painstaking design work of this publication. Angela Barker, Registrar, made sure that all the artwork appeared and disappeared on schedule, maintained budgets and contracts, coordinated artists' travel, events and receptions, and came up with the UFO Frisbee idea. Preparator Karl Rademacher designed the crates for the exhibition's tour and provided installation photography. Matt Pulford, Assistant to the Director, designed the website, reformatted texts, and helped with exhibition and book design. Gallery attendants Devon Depaepe and Nicole Quiring also contributed much time and effort.

I would like to acknowledge the efforts of Roosevelt Newson, Ron Mottram, Paul Berg, Brad Look, Cheryl Budde, Jin Lee, Ted Diamond, and Stephen Taylor in organizing the "College of Fine Arts Festival 2000" of which this exhibition was part. Dave Kuntz's amazing computer expertise kept our craft from crashing.

Finally, the Illinois Arts Council provided funds without which this exhibition and book could not have been realized.

Barry Blinderman
Director of University Galleries

ILLINOIS STATE
UNIVERSITY